PAINTING FLORALS
WITH
Gouache

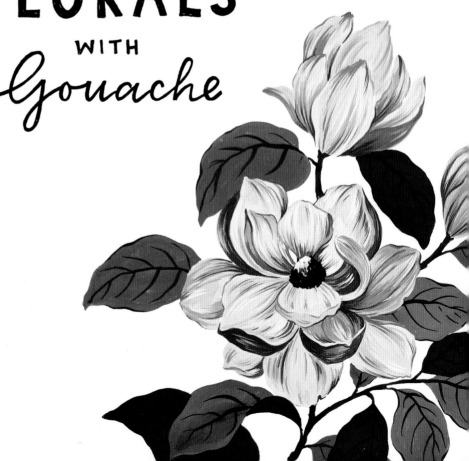

PAINTING FLORALS

WITH *Gouache*

An Introduction to Creating Beautiful
Botanical Artwork with Gouache

VIDHI KHANDELWAL
Founder of The Ink Bucket

PAGE STREET
PUBLISHING CO.

PAGE STREET
PUBLISHING CO.

Copyright © 2020 Vidhi Khandelwal

First published in 2020 by
Page Street Publishing Co.
27 Congress Street, Suite 105
Salem, MA 01970
www.pagestreetpublishing.com

Distributed by Macmillan, sales in Canada by The Canadian Manda Group.

24 23 22 21 20 1 2 3 4 5

ISBN-13: 978-1-64567-128-2
ISBN-10: 1-64567-128-3

Library of Congress Control Number: 2019957305

Cover and book design by Vidhi Khandelwal
Photography by Vidhi Khandelwal and Atul Pinheiro

Printed and bound in China

DEDICATION

This book is dedicated to my mom, who inspired me to take up
the paintbrush at a very young age.

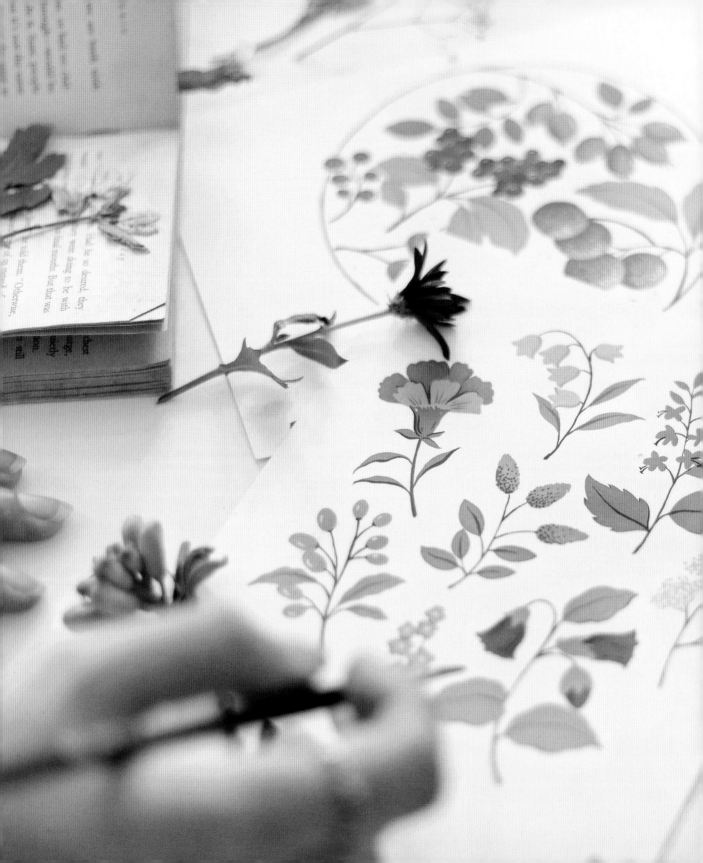

CONTENTS

INTRODUCTION

Hi, my name is Vidhi, and I am extremely excited to share my gouache painting journey with you.

We've all painted with one medium or another at some point in our life, and whether you are familiar with gouache or not, I am sure this book will help you get to know the paint better, create wonderful floral artworks and even help you discover your own gouache style. This book consists of twenty different floral projects, each of which has illustrated step-by-step instructions along with sketches in the back of the book for tracing my designs onto your own watercolor paper.

I think it's safe to say that learning how to paint with gouache changed my life and opened up a whole new world of possibilities. It is the most versatile medium I have worked with, and I got hooked on it in no time. I still sometimes wonder how I spent the first twenty-three years of my life without having worked with gouache at all.

I have been painting for as long as I can remember, thanks to my mother who first taught me how to draw and color and got me excited about painting at a very early age. All through school, I would wait for exams to be over and summer break to begin so that I could start painting.

I love combining botanical illustrations, hand lettering and muted colors. I am also a big fan of the traditional painting process; there's something exciting about an actual brush hitting the paper and not knowing how the final strokes might turn out.

In the beginning, I would try my hand at anything that would come my way, and perhaps by process of elimination, I came to the realization that I loved painting florals. Nature has been the biggest source of inspiration for me with a huge variety of forms and colors to derive inspiration from. No two flowers or leaves are the same, and the same plant or flower can be painted in many different ways depending upon what kind of painting you are seeking. It also lets you explore your own style at every level, whether you are a beginner or a trained artist. If you want to paint a flower green or a leaf black, no one is going to call it wrong, and that's the beauty of nature around us.

Soon, my love for florals and the desire to keep painting turned into a career, and since then I have worked with a number of brands across the world, started my brand The Ink Bucket, painted murals, organized workshops and now turned my dream of writing a book into reality.

Painting with gouache is a form of therapy for me. I would often put on my favorite show on Netflix, have a cup of tea by my side and get lost in color mixing and painting. Having a process in place and enjoying it to the core has been an incredibly rewarding experience for me.

If you are a beginner, I want you to remember that mistakes are a part of the process and there is no escaping them. Do not grow disheartened if something doesn't go right the first time; just remember to enjoy the process and have fun painting with gouache.

When I paint, I start with one layer and gradually build it layer by layer and color by color to achieve a full-fledged detailed artwork. I have broken down every project in this book into simple steps with images to help you take one step at a time and understand the process of painting with gouache from scratch.

I hope that this book helps you build a strong foundation, identify what works best for you and create your own process. I'd love to see your journey and artwork. To share your work with me and the community, please use the hashtag #PaintingFloralswithVidhi.

You can also find my online classes on Skillshare and share your work there for more personal feedback.

Let's get started!

Getting Started with Gouache

Gouache is an opaque, water-based paint with a creamy, velvety finish that dries matte.

A little bit of paint goes a long way. A lot of people refer to it as something between watercolors and acrylics as it is water-based like watercolors and opaque like acrylics. Being a versatile medium, gouache is used by different artists in different ways depending upon their style and experience with the medium.

Having a high level of pigment and an opaque nature, it can be layered heavily, leading to a thick, creamy matte finish, or watered down to a watercolor consistency and used as a translucent or transparent layer.

Another good thing about gouache is that it dries super quickly, and you do not have to wait too long before moving on to the next layer of paint.

I am sure you still have a ton of questions about gouache, so let's get right into the details about everything to do with this medium. Shall we?

WHAT IS THE DIFFERENCE BETWEEN WATERCOLORS AND GOUACHE?

Unlike watercolors, you can paint with the lightest color over the darkest color because of its opaque nature. Because it is more pigmented, it is easy to layer one color on another without losing the pigment or resulting in the two colors getting mixed up. Gouache has a much higher level of pigment and dries faster and more matte than watercolors.

These flowers show layering, with a light color over a dark base.

WHAT IS THE DIFFERENCE BETWEEN ACRYLICS AND GOUACHE?

Acrylics cannot be reused once they dry out. Gouache can be reactivated with water and can be used any number of times.

HOW CAN YOU GET THE RIGHT CONSISTENCY OF GOUACHE?

When I moved from watercolors to gouache, I was mixing a lot of water with my paint out of habit because of using watercolors for so long. The consistency of your paint is important, and ideally you do not need to mix a lot of water unless you are going for a watery effect. For a creamy matte consistency and an opaque texture, add no more than a drop of water to a pea-sized amount of paint.

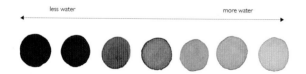

less water more water

Add more water to reduce opacity and for a watercolor effect.

This is definitely something that you'll get the hang of with time and practice.

HOW CAN YOU ACHIEVE THE RIGHT SHADE?

Gouache usually dries out a shade darker, and a slight change in color is bound to happen from wet to dry, so make sure you do a small swatch before using it in your final artwork.

WHAT IF YOU MAKE A MISTAKE WHILE PAINTING?

I can't tell you how many times I have painted over an already painted patch just because I did not like the color or the shape. Because it's opaque, you can easily hide mistakes by waiting for the bottom color to dry and repainting over it.

It's simple and gives you the freedom to experiment without worrying too much about mistakes.

WHY GOUACHE?

The thing that I love most about gouache is that it feels like therapy when I sit down to paint. Once the sketching is done, filling the paint is undoubtedly my favorite part and often helps me keep anxiety away and stay calm. Feeling the creamy paint hitting the paper and watching the pigment form smooth strokes is something I enjoy the most, and I am sure you will agree with me on this once you start painting with gouache. This medium can be used for painting literally anything and is one of the most versatile mediums I have used so far.

Tools and Materials

PAINTS

Investing in good-quality paint might strain your pocketbook, but if you can save up and buy an artist/designer-grade gouache, you will notice a big difference in your art as well as your process.

The brand and quality of gouache paints can be a game-changer, and that is my tip #1 for exploring gouache.

For the longest time, I did not know that gouache existed, and I was mostly using either watercolors, poster paint or acrylics for my work. When I first read about gouache, I was both intrigued and intimidated. I loved the bold opaque look but barely knew anything about the medium and wondered if it was for me.

I decided to put an end to idle curiosity, but since I wasn't sure of this medium and was on a budget, I bought a set of cheap gouache paints.

This first set of gouache was disappointing, and I still wondered how I could possibly achieve a bold, bright, opaque look.

I decided to hit Amazon and buy the best-quality paints available. I ended up purchasing a set of Winsor & Newton designer gouache paints and it made all the difference. The paint was incredibly smooth, opaque and super pigmented, and I haven't stopped using gouache ever since.

After having tried multiple brands and qualities, I am hooked on Winsor & Newton gouache paints. They are the best I have tried so far, and I would highly recommend that brand.

Since I mix a lot of white into my paints, I also use a Mijello Mission White 100-ml gouache tube. It is less expensive than Winsor & Newton and works great for color mixing.

Another brand that I like is Daler-Rowney Designers Gouache, which is highly pigmented and smooth to use.

Having said that, Winsor & Newton is what I use 90 percent of the time and throughout this book.

PAPER

To help you comfortably get started with gouache, there are twenty sketches at the back of this book, one for each project. You have the option of transferring the designs to your own painting paper using carbon paper without worrying about drawing the flowers from scratch. Follow the instructions that come with your carbon paper to transfer the image correctly.

Choosing the right kind of paper is extremely important for any medium, and more so with gouache because it's a water-based paint and the paper you use needs to be able to absorb water and layers of paint. Period.

The kind of paper can literally make or break your artwork, so selecting the kind of paper that best fits your requirements is essential.

Ideally, watercolor paper, anything above 250 GSM (grams per square meter), works great with gouache. I usually use 300 GSM hot-pressed paper for all my artworks because it can hold up layers and layers of thick paint very well. Now, in case you are wondering what hot-pressed paper is, let me get into it.

There are three types of watercolor paper:

Hot pressed: A 300 GSM hot-pressed paper is my go-to paper for all kinds of gouache artworks. It has a very smooth texture with no grain. It has great water absorbency and, because there is no grain on the surface, you can easily paint fine lines and details. I love working with hot-pressed paper for gouache, and I would personally recommend it. It also lets you scan and clean artworks with ease since the background appears flat and is easy to select and remove digitally.

Cold pressed: Unlike hot-pressed, this paper's surface has a slight bumpy texture. It is used widely by a lot of watercolor and gouache artists because of its high water absorbency.

Rough grain: A rough-grain paper has a prominent rough texture on the surface. Because it's highly water absorbent, it can sometimes be a little difficult to control the strokes, and because of this, I am personally not too fond of this paper.

My favorite paper to work with is Canson 300 GSM 100% cotton hot-pressed watercolor paper.

For the projects in this book, I'd suggest hot-pressed watercolor paper in a 300 GSM weight. However, if you prefer a grainy finish, you could choose a cold-pressed or a rough-grain paper too.

BRUSHES

Watercolor brushes work great with gouache. I started with student-grade brushes and still use them sometimes. Anything that is stable, has a nice tip and can give you a streak-free finish should be good.

For the projects in this book, I recommend categorizing your brushes into three types: thin, medium and thick.

- For thin, use brush sizes 00 to 1.
- For medium, use brush sizes 2 to 5.
- For thick, use sizes 6 and above.

Take some time to explore and experiment with your brushes. Dab your brushes in paint one by one and see the kind of strokes you can get when you use the tip, when you keep the brush at a 45-degree angle and when you press it down and use the entire length of the brush.

This small exercise will get you comfortable with your brushes in no time.

Some brands that I love using a lot are DaVinci, Daler-Rowney, Brustro and Winsor & Newton (all synthetic brushes).

EXTRA TOOLS AND MATERIALS

Color palette: Since I love mixing my own colors, I use an airtight color palette that lets me mix and store paints for months.

Paper towel: Always keep a paper towel handy to dab off excess water or paint.

Two water containers: Use one to wash your brushes and the other to mix water into the paint. You don't want to use the same water for the paint as well since the pigment in the water might alter the shade.

Remember to keep your tea/coffee far away from the water containers!

Color Theory

A color palette can make or break an artwork, and I will take you through different ways to create your own palette and not stick to RGB anymore. When I was building my brand and working on the first few collections of printed products, I was scared of color, which is why if you look at my old collections, they are mostly sketched with a black marker with very little color.

I slowly started adding colors, but I eventually found my love for beautiful pastel colors after a lot of trial and error.

Having a good-quality paint is important, but having a huge range of colors, not so much. You can create any shade you want with just five colors on your table: red, yellow, blue, black and white. Sounds brilliant, right? Let me take you through the color wheel first.

PRIMARY COLORS

These are essentially the building blocks of any color palette: red, yellow and blue.

These colors cannot be created using any other color available, so make sure you have these three always.

If you mix these three colors in equals parts, you will end up creating black.

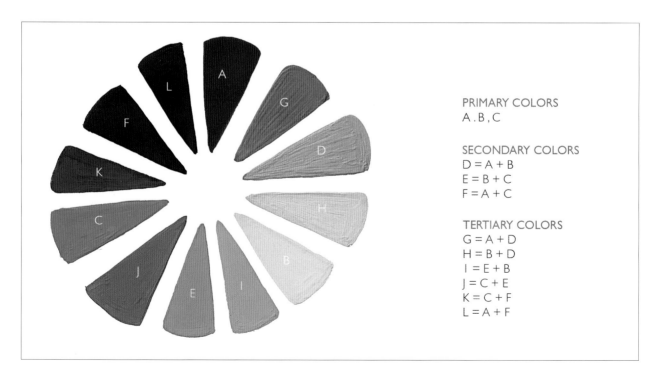

PRIMARY COLORS
A . B , C

SECONDARY COLORS
D = A + B
E = B + C
F = A + C

TERTIARY COLORS
G = A + D
H = B + D
I = E + B
J = C + E
K = C + F
L = A + F

SECONDARY COLORS

These colors are created using any two primary colors in equal parts.

TERTIARY COLORS

These colors are created by mixing equal parts of one primary and one secondary color.

SHADES AND TINTS

The colors on the color wheel (marked from A to L) are in their maximum saturation and brightness and can be turned into either light or dark with the help of white or black. This can lead to either a light or dark color palette depending on how much white or black you decide to mix.

As you mix white in with the colors, you'll start to notice how the brightness goes down and the colors become lighter and more pastel (refer to chart 1).

Similarly, as you add black, you'll notice how the colors get dark, deep and intense (refer to chart 2).

Each time you mix two colors, you are capable of producing different shades just by varying the ratio of the two colors. For example, when you mix red and blue, if there is more red than blue, you are more likely to get a shade that resembles magenta, whereas if the ratio of blue is more than red, you are more likely to get a purple.

There is a color palette laid out for every project along with what colors to mix to achieve that shade. Please know that when I mix colors there is a lot of trial and error. Keep mixing colors in different ratios until you get the color you want. There is no set formula, and the more you practice, the better you will become at color mixing.

Chart 1: Mixing white to create pastel shades.

Chart 2: Mixing black to create darker shades.

Painting Techniques

WET ON DRY

Wet on dry, as the name suggests, is the technique of painting with wet paint over a dry surface or over dried paint.

For example, in the the flower above, the two shades of yellow on the petals appear as different colors and do not merge with each other. The dark yellow strokes were painted once the light yellow background was completely dry.

While using gouache and in the projects in this book, you'll find yourself using this technique a lot. It's a great technique when it comes to creating a bold, layered look or if the intention is not to keep the different layers of paints separate from one another.

TIP: To achieve this technique, do not mix too much water with your paint. Keep the paint creamy and thick so it does not mix with another pigment.

WET ON WET

This technique is generally used a lot with watercolors. Wet on wet is the technique of painting with wet paint over a wet surface. This blends the two layers together, giving you a soft gradation.

The petals of the flower above were painted with two shades of red without waiting for one to dry out completely. You can notice the two shades of red blending with each other without creating any stark strokes.

TIP: To achieve this technique and soft gradation, use enough water with your paint and make it watery, resembling the consistency of watercolors. You could even wet the surface of your paper before applying a wash of paint.

LAYERING

This technique is more or less an extension of the wet-on-dry technique wherein you apply paint over an already dried base layer. There is no limitation to the number of layers you can apply. In this book, we'll use layering in a lot of flowers that we'll paint in the form of texture, shadows and highlights.

As we move on to the projects and we start painting, you'll understand what I am talking about better and get a stronger grasp of this.

In the pink rose above, you can see multiple layers of pink and white on top of each other, creating a beautiful sense of detail.

STIPPLING

Stippling is the technique of adding tiny dots very close to each other gently using the tip of the brush. I find stippling to be the most fun technique ever and almost the star of my artworks, because I end up using this a lot (after layering) mostly for pollen and the centers of the flowers. This technique adds a beautiful and vivid texture to any area.

You can increase the darkness or lightness of an area by varying the number of dots. The denser the dots, the darker the area will be and vice versa.

For example in the flower above, tiny dots cover more than half of the center as well as certain areas of the flower petals.

FLAT APPLICATION

This is the most basic technique and comes in handy when you want to create graphic styles. In this book, most artworks will start with a flat application of a color. It is the process of painting an area with a uniform layer of paint.

Unlike the previous techniques, notice how there is only a single color used for the petals, center and the stem of the flower instead of layering with another color.

LINE DRAWING

The process of adding straight or curved lines to paint an artwork is called line drawing. The lines can vary in size and thickness, and this variation can create shadows when the lines are placed close to each other. When it comes to painting with gouache, line drawing can be achieved by using the tip of a brush and creating thin lines.

In the leaf above, instead of using strokes or a patch of color, I have painted lines from the center to both ends. This technique works great for adding details to leaves or even flowers.

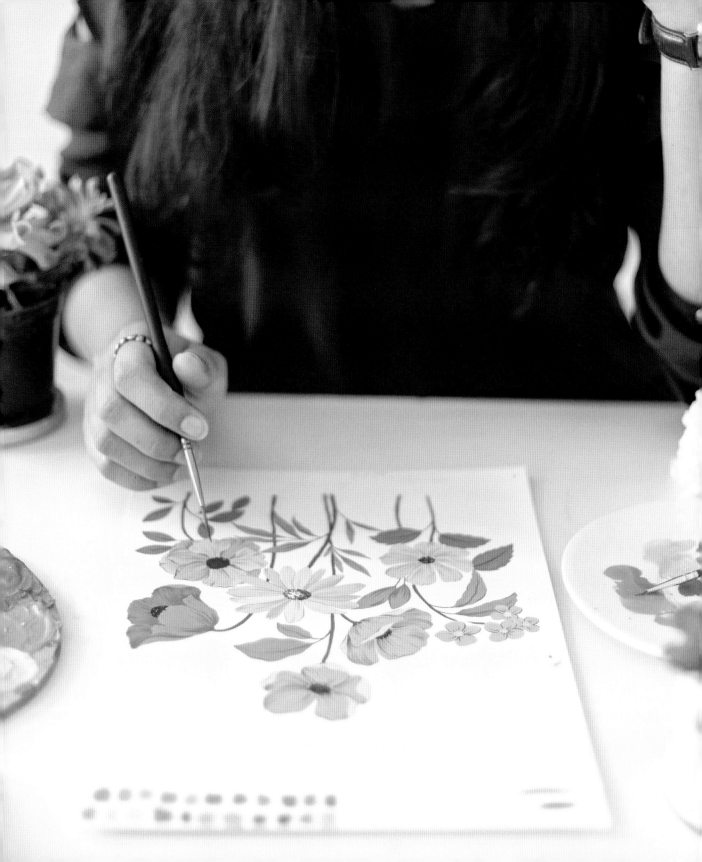

Wildflower Meadow

During the summer of 2019, I traveled across Europe and fell in love with the wildflower fields swaying in the wind. As I watched them like a child from the window of trams and trains, I was fascinated. Having lived in a city all my life, this was something I could only dream of.

The beautiful thing about wildflowers is that they are magical and dreamy in the way they move, grow, fall and look. If you have ever sat down to gaze at a field of wildflowers, you'll know exactly what I am talking about.

Another beautiful thing about them is that most of these flowers are so easy to paint that you don't even need a pencil to sketch them out first. Their simple delicate form can make you fall in love with painting. You can easily pick up a brush and with a few strokes, you will find yourself lost in painting a meadow.

In this chapter, we'll paint some simple wildflowers that will be both therapeutic to paint and beautiful to look at. I am sure that you will start experiencing the joy of painting with forget-me-nots, daisies, lavender, bellflowers, berries, thistle flowers, coneflowers and many more.

This chapter combines the simplicity of painting with attention to delicate forms.

We'll also learn how to combine various techniques like wet on dry, stippling and flat color application alongside others and understand how each technique imparts a unique texture and characteristic.

The opaque nature of gouache will make it easier for you to add depth, and the beautiful color intensity will make the delicate forms stand out. From experience, I have realized that focus on brush strokes, texture and the consistency of gouache is vital while painting wildflowers. Remember not to add too much water to your paint; a drop or two will be enough for you to start painting.

Throw your inhibitions out the window while painting these because there is absolutely no wrong way to paint a wildflower. The more you enjoy it, the better your painting will turn out to be.

Let's begin!

FLORAL SPRAY

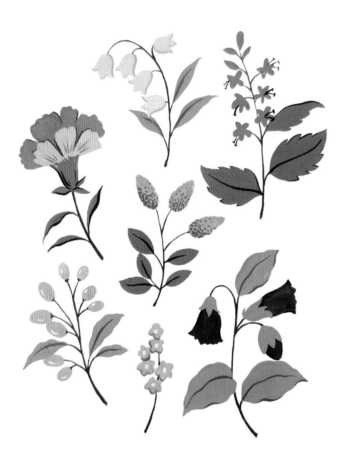

A wildflower-filled meadow is a delight to look at, as well as a great source of inspiration.

This project is one of my favorites in the book because of the different ways in which you can use the wildflowers we'll be painting here.

You can easily use this project to create a beautiful wildflower repeat pattern or use the elements to complement other botanical artworks. The possibilities are many, and they are going to be a breeze to paint.

I have kept this project simple and beautiful, exactly how painting wildflowers feels to me, taking inspiration from bellflowers, forget-me-nots, lilies of the valley, hollyhocks, Drummond's phlox, blazing stars and flower buds.

We'll be using techniques like stippling, flat application and layering. We'll focus on the shapes and colors and by the end of this, you will have a delightful spray of wildflowers with shades of pinks, yellows and a hint of blue.

Start by tracing the sketch in the back of the book, if you like, using carbon paper and transferring it onto your watercolor paper. Follow the instructions that come with your carbon paper to transfer correctly. You can also copy the sketch freehand to practice your drawing skills.

COLOR PALETTE / PAINTS

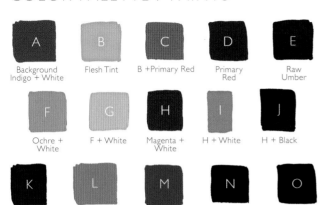

A Background Indigo + White	**B** Flesh Tint	**C** B + Primary Red	**D** Primary Red	**E** Raw Umber
F Ochre + White	**G** F + White	**H** Magenta + White	**I** H + White	**J** H + Black
K Yellow + Black	**L** K + White	**M** Permanent Green + White	**N** M + Black	**O** Charcoal Black

TOOLS AND MATERIALS

Sketch (page 115)

Carbon paper (optional)

Watercolor paper (300 GSM hot-pressed paper recommended)

Round brushes sizes 0, 1 and 2

Gouache paints

Painting palette

Two cups of water, one to wash your brushes and the other to mix with the paints

Paper towel, to clean the brushes and soak up excess water and paint

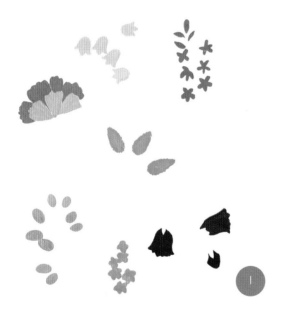

Hollyhock (left top), lily of the valley (top center), forget-me-not (top right), blazing star (center), buds (bottom left), bellflower (bottom right), Drummond's phlox (bottom center).

1. Let's start by tracing or copying the sketch from the back of the book onto your watercolor paper. If you choose to use carbon paper, follow the manufacturer's instructions to transfer the floral design.

Paint the first layer of all the flowers with their respective colors. Starting with the hollyhock, take a size 2 round brush and paint the outside and inside petals with colors B and C respectively, using flat color application.

You could leave a slight gap between the petals, which will later be painted with a darker color.

Next, wash your brush and start painting the first layer of the other flowers the same way. Use color G for the lily of the valley, color A for the blue forget-me-nots, color I for the blazing star, color J for the bellflower, color F for the buds and color C for the Drummond's phlox.

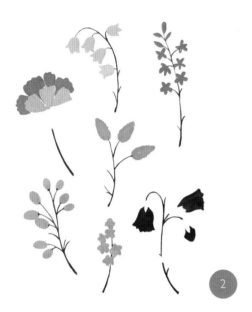

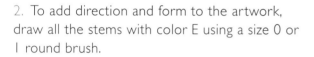

2. To add direction and form to the artwork, draw all the stems with color E using a size 0 or 1 round brush.

Do not worry about having a very smooth line here; a crooked line always makes a better and more natural stem. You could also add a little black toward the end of all the stems. Wait for a minute to let the paint dry before moving on to the next step.

3. Now that the direction and form are defined, paint the leaves of the flowers with different shades of green, colors L and M. Use a size 2 round brush and again don't stress too much about making them uniform. Add curves, waves and bends to the leaves using the tip of your brush.

4. Use techniques like stippling, single stroke line drawing and wet on dry to add shadows and details to the flowers and buds. For this we'll use the tip of the size 1 brush and one shade darker than the base color.

Wait for the base layer to completely dry before moving on to this step.

For the hollyhock, take color C and, using the tip of a size 1 round brush, paint small strokes starting from the center to the edge on the outer petal. For the darker inner petal, use the same brush and color D to paint the white gaps in between the petals, inner bends and corners.

Moving to the yellow lily of the valley, with color F paint the bottom edge of the flower. Consider the light to be on the top, and the bottom part to be a bit darker than the top.

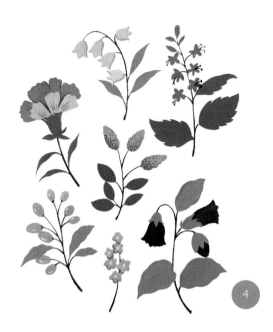

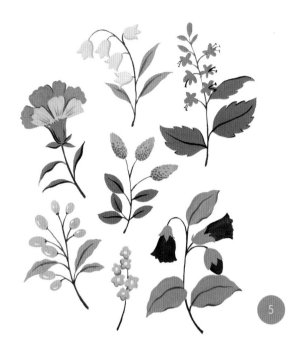

For the blue forget-me-nots, exaggerate the center by painting stamens outwards with black, color O. Use the tip of the brush and start from the center of the flower. Add a small horizontal line to the end of each stroke.

Now, let's move on to the blazing star flower in the center. For this, we'll use the tip of our brush and stipple. Take color H and start stippling at the bottom base of the flower and move your way up. Keep the dots closer together at the bottom, reduce the density as you go up and end it at about three-quarters length.

For the buds, we'll create a highlight stroke to show the light reflected by the round shape. Take the color white and paint a small round near the left edge of each bud.

The next flower is the phlox. For this take color C and paint an outline on the bottom left of each flower. Complete this by adding a white center.

For the bellflower on the bottom right, take charcoal black (color O) and paint strokes at the base and toward the edge. Paint along the bends of the flower and vary the size of the strokes for a more natural look.

If you want the colors to merge together, you could also use a wet-on-wet technique and add the second layer before the first layer dries.

5. Take darker shades of greens, colors N and K, and paint the veins of the leaves with a size 0 round brush. Start pressing the tip of the brush at the starting point of the vein and gently lift the tip up as you reach the edge of the leaf.

Using the same colors, paint in turns on the edge of the leaves, this will help create shadows. Consider this as a broken outline to the leaf.

MIXED ROUND BERRIES

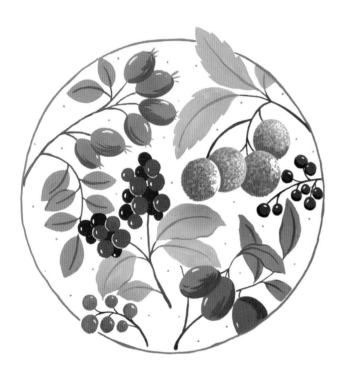

Along with wildflowers, berries add life to a composition. They taste amazing, are beautiful to look at and even more fun to paint.

Most berries that we see around—blueberries, cranberries, wild berries, cherries—are in shades of blue or red, so that's the color palette I decided to keep for this project as well. A lot of these berries grow in the wild along with flowers and beautifully complement floral compositions.

If you look at the sketch, the berries are in a big circle. This is a layout you can follow for any project by drawing a shape first and filling it up with different elements. This style pulls your artwork together, especially where elements are randomly placed.

We are going to be using pretty much the same techniques as the previous project with a little more stippling and attention to the round form of the berries.

Depending on the type of berry, they could have a smooth surface or a textured one; in this project we'll learn how to paint both using techniques like flat application and stippling.

Keep your colors ready with a creamy to slightly watery consistency, and let's start painting.

COLOR PALETTE / PAINTS

A	B	C	D	E	F
Spectrum Red + White	Flesh Tint + Spectrum Red	Flesh Tint	Background Indigo + White	D + White	Blue + Red

G	H	I	J	K
F + White	Green + White	Yellow + Black + White	Green + Black + White	Raw Umber/ Brown

TOOLS AND MATERIALS

Sketch (page 116)

Carbon paper (optional)

Watercolor paper (300 GSM hot-pressed paper recommended)

Round brushes sizes 2 and 1

Gouache paints

Painting palette

Two cups of water, one to wash your brushes and the other to mix with the paints

Paper towel, to clean the brushes and soak up excess water and paint

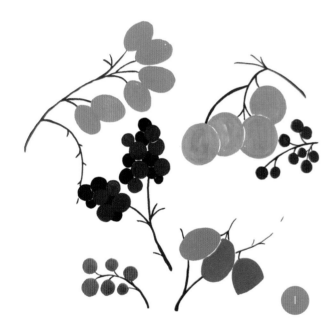

Blueberries (top left and bottom right),
raspberries (top right), black currants (center and right),
cranberries (bottom left).

1. Trace or copy the sketch from the back of the book onto your watercolor paper. If you choose to use carbon paper, follow the manufacturer's instructions to transfer the design. In the first step, we'll use colors A, B, D, E, F and G and cover the base of all the berries with different shades of blues and reds. Take a size 2 round brush and with the tip of the brush, start painting the outline and slowly move the paint inside to complete the oval or the circle.

Wherever there is an overlap, leave a little space; it will almost look like a one-sided uneven white outline.

With the tip of the same brush, start painting the stem with color K. Start from the base of the stem and keeping your wrist firm on the table, move your palm in the direction of the berries.

2. Now, we'll start painting the details of the raspberries on the top right. For this, take color A and, with a size 1 brush, start stippling from the leftmost end of the circle toward the right, covering a little more than half of the circle. Decrease the density of the stippling as you move toward the right. Can you see overlaps of the berries becoming more prominent now and the formation of shadows?

3. While the layer in step 2 dries, we'll add details to the rest of the berries using a size 1 round brush.

Take a darker shade of blue, color D, and start painting on half of the outline on one side of each blueberry. Follow this by adding smaller strokes inside the berry along the outline in a curved manner.

For the black currants in the center, paint one-quarter of the outline using color C on the lighter berries to define the round shape; this almost operates as the area reflecting light.

For the raspberries, on the top right, take color C and start stippling from the right side of the berries, covering just about one-quarter of the circle and reducing the number of dots by painting them farther apart as you move toward the center.

For the red cranberries on the bottom left, mix a hint of color K with color A and use this to paint half the outline on the left of each berry.

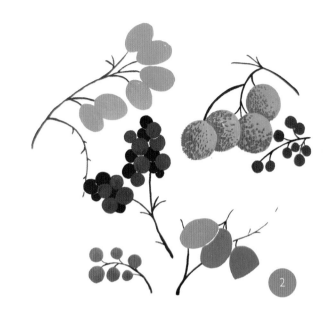

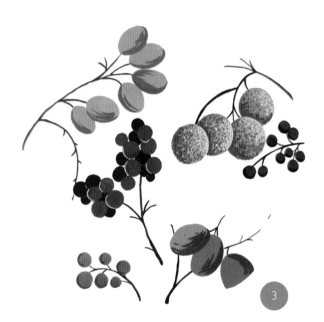

4. Our shadows are now done, and it's time to move on to the highlight strokes. These are going to be shorter and on the opposite side of the shadow strokes that we painted in the previous step.

For the large blueberries and red cranberries, take the color white and create tiny round strokes just a little away from the outer edge of the berries.

For the black currants, these strokes would be on the same side and an add-on to the previous highlight outline that we made in step 3.

For the raspberries, instead of a curved stroke, stipple a little on the right of each berry.

Once the berries are done, paint the three different types of leaves with colors H and I with a flat color application.

You'll be able to notice the beautiful contrast between the colors of the berries and the leaves at this stage.

5. Complete the leaves by painting the veins with colors I and J. Paint them in the same direction as the bend and curve of the leaf.

Now, paint the outline of the circle with a black color (you could use the color of your choice) using the tip of a size 1 brush and a smooth motion of the wrist. You could either start at one point and go all the way around or rotate the paper for a smooth circular outline.

To complete the artwork, paint tiny dots inside the circle to add a more finished and dreamy look to the berries.

DELICATE PHLOX

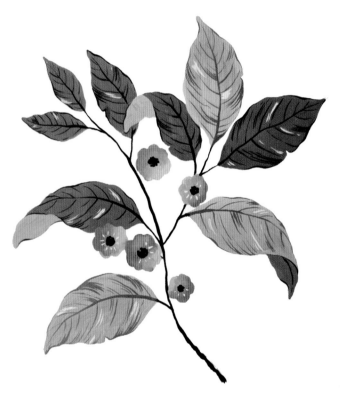

Oversized leaves and tiny flowers are cute as cute can be.

In this project, we'll paint phlox, small round flowers with a delicate center and big leaves. They are usually found in clusters in various colors. At times, it's refreshing to not paint the flower exactly as it looks; instead, take inspiration from one or more characteristics that stand out for you and paint your own version.

We'll experiment with a subtle gradation using wet-on-wet technique and focus on the details of the leaves a lot more using wet-on-dry technique.

The use of a single-color flower on a stem alongside bright green leaves makes for a calm, soothing artwork that can either be used as a big minimal print or as an add-on to an existing bunch.

Though this is a simple gouache project, I hope that your confidence in gouache goes to the next level.

COLOR PALETTE / PAINTS

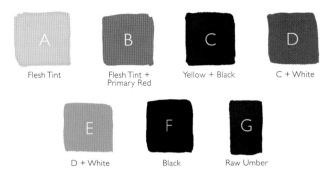

A — Flesh Tint

B — Flesh Tint + Primary Red

C — Yellow + Black

D — C + White

E — D + White

F — Black

G — Raw Umber

TOOLS AND MATERIALS

Sketch (page 117)

Carbon paper (optional)

Watercolor paper (300 GSM hot-pressed paper recommended)

Round brushes sizes 2, 4 and 1

Gouache paints

Painting palette

Two cups of water, one to wash your brushes and the other to mix with the paints

Paper towel, to clean the brushes and soak up excess water and paint

1. Trace or copy the sketch from the back of the book onto your watercolor paper. If you choose to use carbon paper, follow the manufacturer's instructions to transfer the floral design.

Take color A and keep the consistency just a bit more watery than usual by adding an extra two or three drops of water so that the paint flows enough for a wet-on-wet application (somewhere between opaque and translucent). With your size 2 brush paint the flower with a uniform wash of this color. While this layer is still wet, quickly move on to color B and, keeping the same consistency, paint one side of the flower and let it naturally mix and merge with the base layer. If the two layers are watery enough, the colors will flow together as soon as the second color hits the first. If not, you could also add a bit more water to reactivate the center of the flower and make the two colors mix together.

We'll come back to the flowers later.

2. Now that we have the base of the flowers laid out, let's move on to the leaves. Use two different colors for the leaves because if you look at a plant, you'll always find a color variation in its leaves.

Use colors D and E to paint the base of the leaves with a size 4 round brush. A lot of times, the back and the front of a leaf have different colors, and the bend of the leaves are nothing but another side of the leaf folding and being visible. For the leaves that have color D as the base, paint the bends of those leaves with color E, and vice versa.

Pay attention to the shape of the leaf here; the center is wider and the end is narrow and slightly elongated at the tip. Use the tip of your brush and alter the pressure of the brush while moving along the outline of the edges of the leaves to get subtle waves and cuts. When you are painting the base layer, keep in mind all these little features of the big leaves so that the shape doesn't turn out to be flat.

3. We will now start adding details to the leaves starting with the lighter leaf. Take color D and first paint the main vein (midrib) of the leaf. Start from the base center, and reduce the thickness of the midrib as you approach the end.

Next, paint the side veins in both directions and start adding strokes to create shadows and texture in the direction of these veins from the side of the leaf toward the center and some from the center towards the edges. It's very important to keep the direction of the strokes the same as the side veins and slightly curved. Look at image 3B for a close up of the leaf detail.

4. Repeat step 3 for all the leaves. For the remaining leaves with color E as the base, use color C for the details. In this step you are doing exactly what we did in the previous step, using a different color.

Once this is done, notice the waves on the ends of the leaves. Take the color of the vein and paint the areas where the waves at the edges take a dip. These are essentially the areas where the edges of the leaf fold inwards and do not receive as much light and form the shadow areas.

5. Paint small white strokes along the veins to form highlights. These are the areas that are curved and reflect light. Repeat this step on all of the leaves. Unlike the shadow strokes, do not paint too many white strokes; keep them small and thin.

Think about makeup and adding a highlighter to your face. You'd do it at the end and cover a much smaller area than compared with a blush or a bronzer. Right?

It's pretty similar here as well.

Coming back to the flowers, paint the center with a gentle stippling motion with color F. Add white strokes unevenly around the center of the flower, keeping them small.

Right now, everything seems to be in the air, so let's paint the stem that connects the flowers and the leaves.

Take a size 1 round brush and, keeping it at a 45-degree angle, paint the stem with color G and a slightly shaky hand just so that the stem is a little wavy and not too smooth.

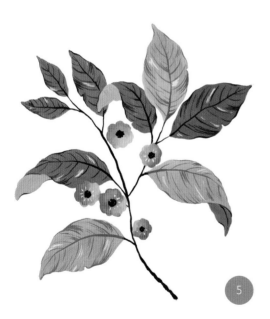

LAVENDER AND DAISY

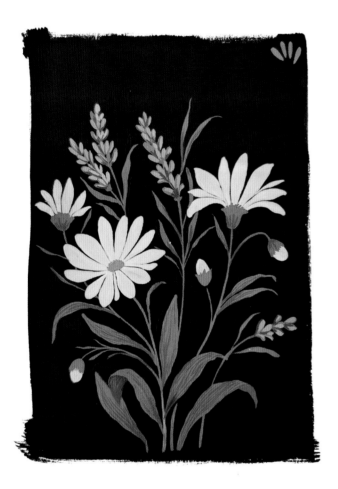

The great thing about gouache is that the lightest color can be layered on the darkest, and we'll be using that technique in this project to create a field of daisies and lavender on a black background.

This is something that watercolors won't let you do. Painting with light colors or creating white flowers on a white background is not always so fun. In these cases, a black background can make the colors pop and make white flowers visible.

Unlike our previous projects, we will not transfer the sketch first because the black background will hide it. We'll paint the background first, wait for it to dry completely and then sketch out the florals.

This project will also set the tone for other similar compositions in the next few chapters and any artwork you create with colored and dark backgrounds or even a nighttime landscape.

The consistency of the paint is going to be the key here.

COLOR PALETTE / PAINTS

A — Green + Grey

B — A + White

C — Prussian Blue + Red + White

D — C + White

E — C + Black

F — Ochre

G — Charcoal Black

TOOLS AND MATERIALS

Sketch (page 118)

Carbon paper (optional)

Watercolor paper (300 GSM hot-pressed paper recommended)

Pencil

Flat brush size 6

Round brushes sizes 4, 1 and 0

Gouache paints

Painting palette

Two cups of water, one to wash your brushes and the other to mix with the paints

Paper towel, to clean the brushes and soak up excess water and paint

1. We'll start by painting a coat of color G on the paper. Take a flat brush in size 6 or above and start painting flat strokes in vertical and horizontal directions until you get an even coat.

Wait for about 5 to 10 minutes for the background color to dry completely, then trace or copy the sketch from the back of the book onto the watercolor paper. If you choose to use carbon paper, follow the manufacturer's instructions to transfer the floral design.

TIP: You can also use a thick black sheet of paper for projects like these (make sure it's over 250 GSM and absorbs water).

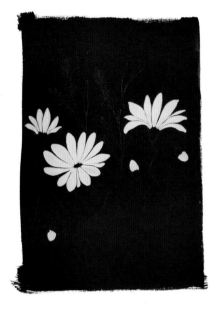

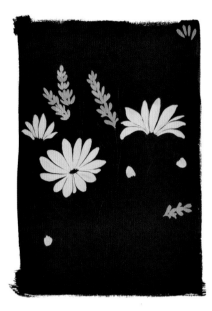

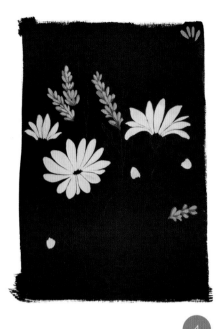

2

3

4

2. In the meantime, prepare the colors to be used for the flowers and leaves: lavender, white and green.

Take white gouache and mix it with just a few drops of water to get a rich, creamy consistency that is smooth enough to paint with. With a size 4 round brush start painting the petals of the daisy flowers as well as the buds. Remember to keep the consistency smooth but not watery because that can reduce the opacity of the color. Keep the quantity of water as low as possible and do not worry about the edges being too smooth; rough edges always give a more natural look.

3. Take the lightest shade of lavender, color D, and start making the tiny petals almost in the form of an inverted drop with a size 1 brush. Try to paint each petal with a single brush stroke and a slight color variation to add differentiation and interest.

On the top right corner, I have painted the petals separately to give you a clearer idea. Also, leave a slight space between the rows; this will be an indication to add a darker shade in the coming steps and create shadows.

4. So far, we have the base of our flowers ready. Now, take a deeper shade of lavender, color C, and add shadows on the bottom and sides of the petals. Make sure it's not too even or it ends up looking like an outline. You want to pick one side, either the right or the left, and the bottom.

Once done, take the final dark shade of lavender, color E, and paint at the bottom of certain petals to add depth.

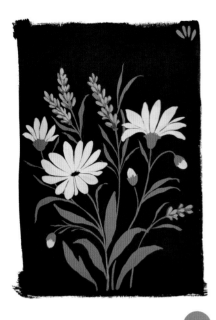
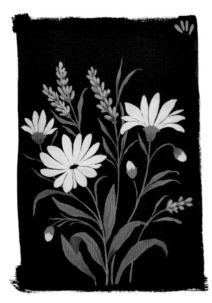
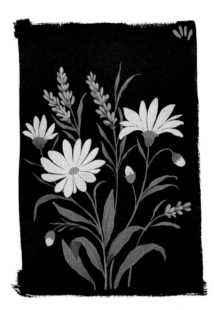

5

6

7

5. Our flowers are almost done and it's time to get to the leaves. Pick up the lighter shade of green, color B, and paint the stems and leaves with a flat application. This will form the base of our leaves.

6. Take the darker shade of green, color A, and start painting uneven lines starting from the point where the leaf originates to the end. Use a fine-tip brush, size 0 or thinner, for this. Not all lines have to be the same length. Use the tip of the brush for this and try lifting it up as you go toward the edge.

Paint the folds of the leaf with this darker shade as well.

7. In the final step, paint the center of the daisy with a yellow ochre, color F, in a gentle stippling motion.

MEADOW IN BLOOM

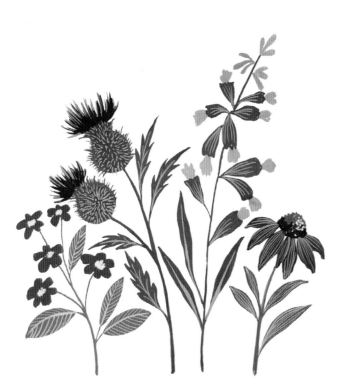

For most of the projects in this book, we have gone from light to darker layers, whereas in this project, we'll do the opposite. One of the major differences between gouache and watercolor is its ability to layer the lightest color on the darkest because of its opaque nature, and this forms the base of this project. You cannot achieve this with watercolors, and this is one of the reasons that gouache is such a great medium to work with.

We are going to paint the darkest color first and create a delicate look by painting fine lines with lighter tones.

With flowers like the thistle flower, purple coneflower and cowslip, this artwork is playful and has an understated charm. We'll notice how simple lines can add a stunning texture and make an artwork look fresher.

I hope this project inspires you to paint a whole meadow instead of stopping at the last step.

COLOR PALETTE / PAINTS

A	B	C	D	E	F
Prussian Blue + Red + White	Prussian Blue + Red	Spectrum Red + Blue	C + White	Ochre	Spectrum Red + Grey

G	H	I	J	K
Green + Grey	G + White	H + White	K + Red + White	Raw Umber

TOOLS AND MATERIALS

Sketch (page 119)

Carbon paper (optional)

Watercolor paper (300 GSM hot-pressed paper recommended)

Round brushes sizes 2, 1 and 0

Gouache paints

Painting palette

Two cups of water, one to wash your brushes and the other to mix with the paints

Paper towel, to clean the brushes and soak up excess water and paint

1. Trace or copy the sketch from the back of the book onto your watercolor paper. If you choose to use carbon paper, follow the manufacturer's instructions to transfer the floral design.

Let's start with the thistle flower. Take a size 2 round brush and paint the bud, leaves and stem with color G. For the thorn-like long narrow petals, take your size 1 brush and, starting from the base, paint strokes with a quick smooth motion of the brush using color B.

2. With color I and a fine-tip size 0 brush, paint the veins of the leaves. For the lower round part of the flower, paint small lines starting from the center and moving in all directions. A good way to do this is to keep the direction of your lines the same but keep rotating the paper; this way your hand stays stable.

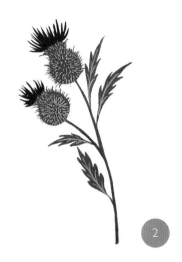

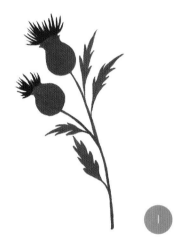

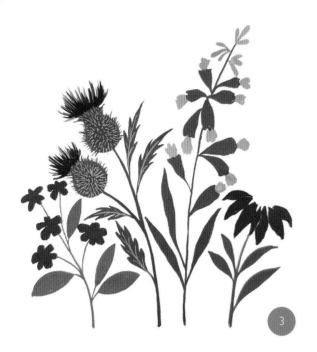

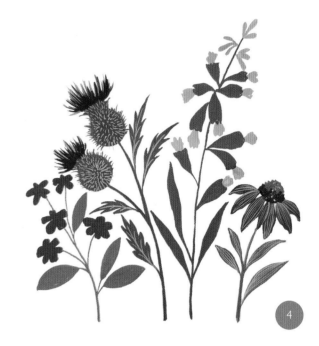

3. Repeat step 1 for all the flowers, painting them in their respective colors. Use color F for the flower on the extreme left, color E for the tall cowslip and color C for the petals of the purple coneflower.

Coming back to the thistle flower, take color A and with a size 1 round brush, paint a few short petals just behind the petals we painted in step 1, following the same brush movement. Paint the leaves of the tall cowslip with color G and a round size 2 brush. Paint the leaves of the small wildflower on the extreme left and the purple coneflower on the extreme right with color H and a round size 2 brush.

This will form the base for our artwork.

4. From here on, we'll only be using a fine brush: size 0 or 1. For the purple coneflower on the extreme right, take color D and start painting fine lines from the center of the flower to the ends of the petals. Curve the lines as the petal curves.

Repeat the step for the leaves but with color I this time.

For the center, stipple with color K at the base and color J at the top to add a sense of depth.

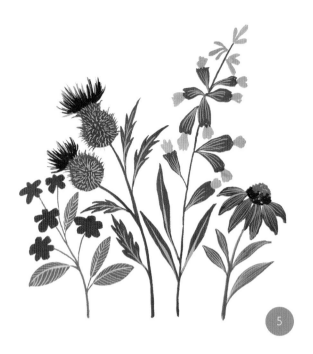

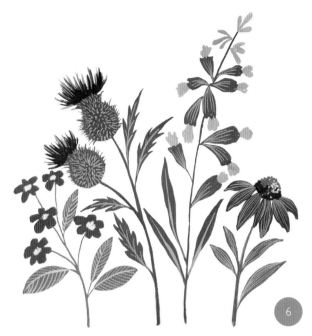

5. Using color I, paint the veins for all the remaining leaves. Keep the lines fine and as close to each other as you want.

To make it look more natural, vary the thickness of your lines from time to time by increasing or decreasing the pressure of the brush.

6. For the final touches, add the white pollen to the center of the red flowers on the extreme left. Now, stipple with white on the center of the purple coneflower on the extreme right to add a highlight.

Voilà—we are done!

Romantic Garden

Before we move to this chapter, I want you to do a small exercise. Close your eyes and visualize a garden tea party or brunch. The table is set, and there's a beautiful floral arrangement in the center with big roses, peonies, hydrangeas, ranunculus, anemones, eucalyptus, daisies with berries, lavender and a few berries hanging around.

When I first started painting, I was obsessed with these large romantic flowers, their chic appeal, earthy charm and beautiful pastel color palette. They sure do evoke a certain mood, and even today when I paint these flowers, I feel the same old thrill.

We can all agree that flowers like roses radiate a certain charm, but painting them might not always be the easiest. Believe me, if you can break the shapes down and take one step at a time, you'll get the hang of it in no time, and that's exactly what we'll cover in this chapter, one stroke at a time.

Through various projects in this chapter, we'll get to the basics of painting complicated flowers and breaking them down into fun steps. We'll also learn how to create that perfect chic color palette with a vintage charm and, through muted colors, bring out the essence of a romantic English country garden.

With practice, you'll develop a practical understanding of strokes, shadows, curves and details and realize how a carefully selected color palette and a balanced arrangement could serve as the foundation for a serene, romantic bouquet.

A ROSE BUNCH

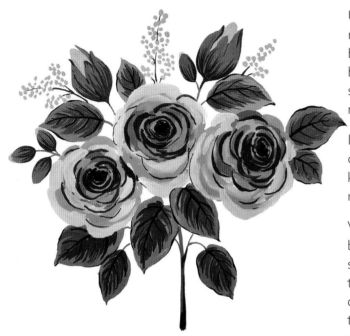

Undoubtedly, roses are considered to be the most romantic flowers by many. From a tightly wrapped bud to the overlapping petal structure of a full-blown flower, a rose can be painted in a number of styles and angles. It's a versatile flower, and there is no one correct way to paint a rose.

In this project. I'll share with you a fun way to capture the top angle of a rose and paint a tight knit bunch that will exude simplicity, fun and romantic charm all at once.

We'll play around with a bit of wet-on-wet bold brush strokes to create subtle suggestions of shadows, highlights on the edges of the petals and the flamboyance of a rose. This way, we'll be creating the outer edges of the petals by controlling the pressure of a brush and creating arc-like strokes.

To better understand what I am talking about, let's move on to painting right away.

COLOR PALETTE / PAINTS

A	B	C	D
Primary Red + White	A + White	B + White	Primary Red + Black

E	F	G	H	I
Yellow + Black	E + White	Green + Black	Charcoal Black	Prussian Blue + Red + White

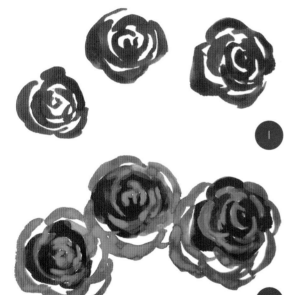

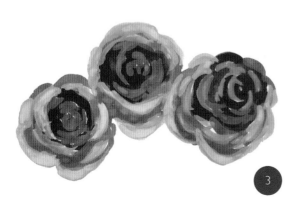

1. Trace or copy the sketch from the back of the book onto your watercolor paper. If you choose to use carbon paper, follow the manufacturer's instructions to transfer the floral design.

Start the first layer with a midtone, color A in this case. Add just enough water to get a smooth consistency, and with a size 2 round brush, paint uneven crescent-shaped curved strokes for the petals. Start from the center and increase the size and distance of the strokes are you go outward.

2. When the first layer is semi-dry, take a lighter color, color B, and paint the same way, covering up the white area formed by step 1. Keep painting the curved strokes for the remaining part of the flower as well, following the same steps and leaving some gaps in between.

3. Paint the white area that is left with the lightest shade, color C, while the second layer is still 20 percent wet. Wait for this arrangement to dry up completely. This will form the base of your rose.

4. Once the layers have dried, take color D and create thin curved stokes with a size 1 or 0 round brush. Keep the strokes thin at the beginning and end of the stroke and thicker in the center. For this, you can start with the tip of the brush, flatten it as you curve and lift it again when you end it.

Keep the strokes smaller, more curved and closer at the center and increase the size and distance as you move away from the center. Keep the direction the same as the strokes in the previous steps.

5. Take a charcoal black, color H, and start stippling at the center of the flowers for added depth. Next, take your size 2 round brush and paint the base layer of the leaves with color F. The edges of the leaves have crooked and slightly curved lines, while the tip of the leaf is slightly sharp here.

6. With a darker shade of green, color E, and a size 1 round brush, draw the main vein. Paint short strokes starting from the vein outwards, creating a dark patch in the center of the leaf. You could also use a thin flat brush for this.

7. With color E, paint the buds with a flat layer of paint. With the darkest shade of green, color G, paint the veins of the leaves. Also, paint the stems to create the form of the bunch.

Next, use a lavender color, color I, and with the tip of a size 2 round brush, gently stipple, creating small circles for the flowers.

8. With color G, add another layer to the buds by painting strokes with a size 0 round brush. Start from the base of the buds and gently move upwards using the tip of your brush.

Paint the little flower popping up from the two buds on top with color C to finish off this artwork.

BLACK-EYED SUSAN

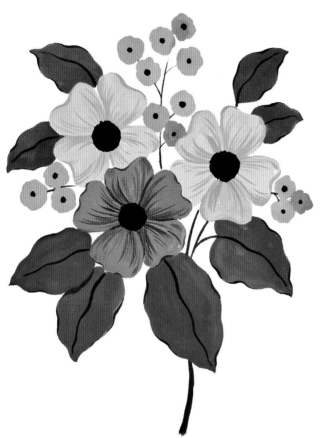

In this project, we'll be creating a bunch of flowers inspired by the form of *Thunbergia alata*, commonly known as the black-eyed Susan. These beautiful flowers are found in vibrant shades of yellows and reds with a very prominent black center, hence the name. To complete the bunch, we'll paint some yellow ochre wildflowers surrounding the black-eyed Susan, and by the end of this project, you'll have a ready-to-frame artwork.

We'll be focusing on simple flat opaque application and explore the striking contrast between warm pastel tones and Winsor greens. For the flowers, we'll use wet-on-dry single layer application as well as stippling for a slight texture.

COLOR PALETTE / PAINTS

A	B	C	D
Flesh Tint	Flesh Tint + Burnt Sienna	Flesh Tint + Primary Red	Primary Red + Burnt Sienna

E	F	G	H	I
Black	Ochre	Winsor Green + White	Winsor Green + Black	Burnt Sienna

TOOLS AND MATERIALS

Sketch (page 121)

Carbon paper (optional)

Watercolor paper (300 GSM hot-pressed paper recommended)

Round brush sizes 4, 2, 0 and 1

Gouache paints

Painting palette

Two cups of water, one to wash your brushes and the other to mix with the paints

Paper towel, to clean the brushes and soak up excess water and paint

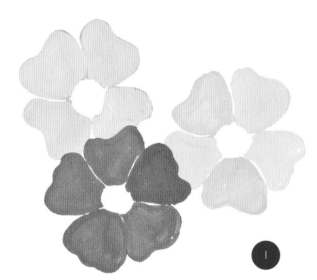

1. Trace or copy the sketch from the back of the book onto your watercolor paper. If you choose to use carbon paper, follow the manufacturer's instructions to transfer the floral design.

Take a round brush in size 4 and paint the petals of the black-eyed Susans with colors A and C, without mixing in too much water. This should be an opaque layer.

Wherever there is an overlap between the petals, leave a little space to ensure you don't end up with a big blob of paint. This forms the base of our flowers.

2. Wait for the base layer to dry and pick up a round brush in size 0 (or any extra fine–tip brush) for the second layer on the flowers.

Take colors B and D and start adding strokes from the center to the edge of the petals. At this stage, also paint the gap between the overlaps that we had left in step 1 and along the curves on the edge of the petals, creating shadows and a sense of depth.

Again, pick your size 2 round brush and start painting the center of the flowers with color E in a stippling motion.

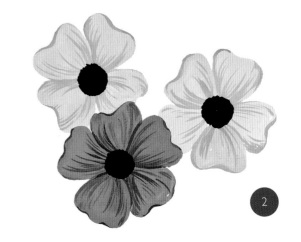

3. Now that the flowers are done, we'll move on to painting the leaves.

Take a size 4 round brush and and give the leaves a flat coat of color G. You could even mix a little white if the base color seems too dark.

Next, take a fine-tip round brush, size 0, and paint the main vein with color H. Start from the base of the leaf using a slight pressure on the tip of the brush and slowly move to the edge while lifting the pressure.

Repeat the above step for the curves on the leaf, the areas where the leaf folds inwards.

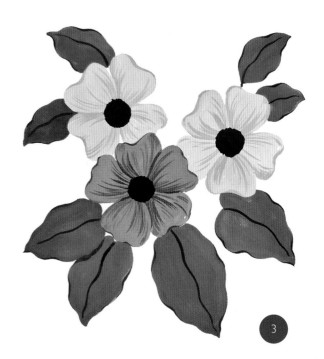

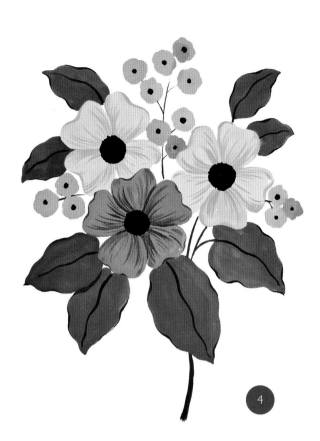

4. In this last step, we will add the final wildflowers and paint the stems to connect the flowers and leaves.

Take a size 1 or 2 round brush and paint the wildflowers with a flat opaque coat in color F, keeping the edges slightly rough for a natural look. Finish them by adding the center with color E.

Take your fine-tip brush and paint the stems with color I. Try to use the tip of the brush and create strokes that are thinner toward the base of a leaf or a flower and thicker toward the start of the stem.

Our black-eyed Susan bunch is now ready.

ANEMONE AND POPPY GARDEN

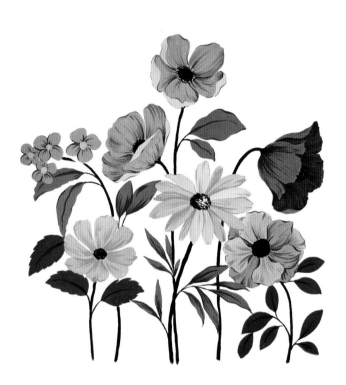

This artwork might look just a tad bit complicated at first but let's take one flower and one step at a time, and I am very confident that by the end of it you'll be able to paint this with ease.

All these flowers that we'll be painting, like cosmos, anemones, yellow daisies, poppies and forget-me-nots, have a different structure and color palette, and dealing with multiple flowers in a single artwork can be a little tricky at times.

In this project, we'll learn how to paint a big cluster together, how to add details one step at a time, where to pay more attention and how to balance the tones to enable the eye to move all over. For instance, we'll keep the leaves simple and use intricate line drawing to bring out the beautiful texture of a poppy.

We'll be using a lot of colors here, so grab a nice big palette and let's start painting.

COLOR PALETTE / PAINTS

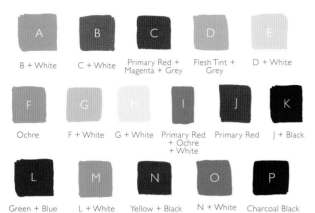

A	B	C	D	E	
B + White	C + White	Primary Red + Magenta + Grey	Flesh Tint + Grey	D + White	
F	G	H	I	J	K
Ochre	F + White	G + White	Primary Red + Ochre + White	Primary Red	J + Black
L	M	N	O	P	
Green + Blue	L + White	Yellow + Black	N + White	Charcoal Black	

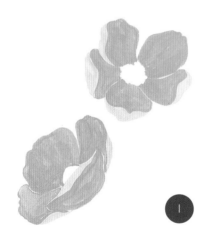

1. Trace or copy the sketch from the back of the book onto your watercolor paper. If you choose to use carbon paper, follow the manufacturer's instructions to transfer the floral design.

Let's start with the anemones at the top. If you look at the petals, they are curved in such a way that you can see the other side of the petal turning in. Paint the top of the petal with color A using a size 4 round brush. For the turns, mix white with color A in the palette and use that color. Leave a little space between the petals and on the overlapping areas, just enough to know where the next petal starts. Use a size 2 round brush for smaller areas.

2. Paint the white areas that you had left in the previous step and, using color B and a size 0 round brush, start adding strokes starting from the center to the ends of each petal. When you do this, paint the strokes in a curved form, resembling the shape and direction of each petal.

Once the texture on the petals is done, paint the inner center of the flowers with charcoal black, color P. On the outer ring around the center, use stippling to create a texture.

3. To add the final touch and shadow on the anemones, use color C and with a size 0 round brush, paint the areas where the petals overlap. Also, paint on some of the "in" turns on the edges of the petals.

Use very little of this color because you don't want to hide the nice texture that you had painted earlier.

Following the same steps, paint the third anemone at the bottom. The only difference here is the use of two base colors, color A and color A plus a tint of white, instead of one.

Now, paint the base layer for the poppy with color I for the outside of the petal and J for the inside. Keep the petal wavy towards the edges.

4. In this step, we'll add details to the poppy in the form of thin fine lines using color J for the outer petal and color K for the inner petal, starting from the base of the flower to the edge. These lines are curvy and move in the same direction as the petal. Try to alter the size, length and thickness of these lines to create a more natural-looking texture.

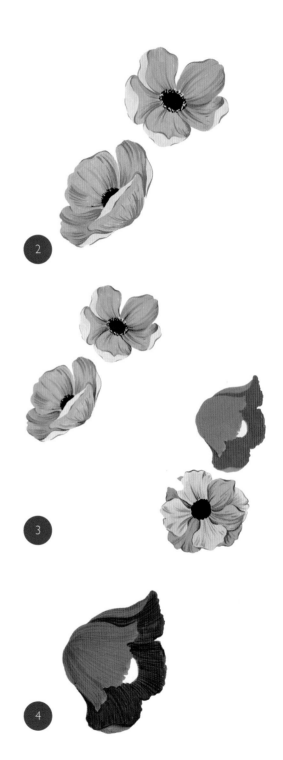

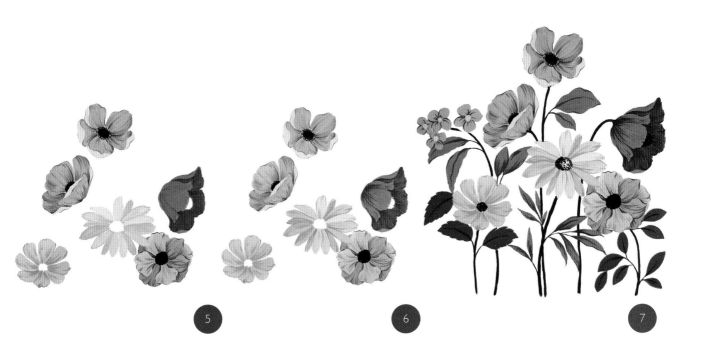

5. Paint the cosmos next in shades of peach. You follow the exact same steps as the anemones except for the change in color. Use color E for the base and D for the strokes on top. After this, paint the petals of the yellow daisy with two different shades of yellow, colors G and H, leaving a tiny gap between two petals.

6. Add details to the daisy with a size 0 brush and color F. Paint strokes starting from the center toward the end of the petals and a few strokes starting from the ends, keeping these strokes shorter.

To add shadows to the poppy, take color K and start painting short strokes from the base of the flower. On the inside of the poppy, paint on the overlaps and a few strokes coming from the center to the edges. Also, paint the extreme corners and on the edges of the petal where there is an inward turn.

7. Paint the base layer of all the leaves with different shades of green, colors N and O, using a size 2 round brush. Keep the consistency of the paint creamy and thick for a rich flat coat. Keep the ends of some leaves wavy. Once this layer dries, take the darkest shade of green, color L, and paint the veins of the leaf starting from the base of the leaf toward the end. Hold your brush at a 45-degree angle when you start the vein and gently move to the tip of the brush and eventually lift the brush up closer to the end of the leaf.

For the last flower, the forget-me-not, paint the base layer with a coat of color M and once it dries, add strokes with color L and a size 1 round brush, starting from the center and on the overlap of the petals. Finish this by painting the center with yellow, color G.

To complete the poppy and the cosmos, stipple at the center using color P. For the daisy, start stippling around the center and slowly reduce the density as you approach the right center.

MAGNOLIA BRANCH

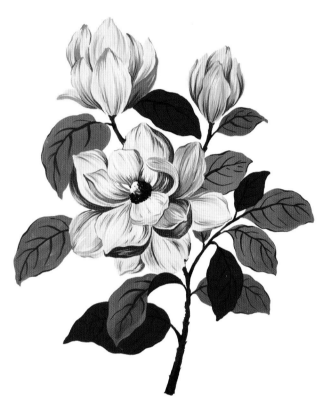

The magnolia is a magnificent flower often found in shades of white with a hint of pink. These flowers have big, flowy overlapping petals with a striking center. In fact, the entire flower radiates a sense of calm and looks almost dreamy in full bloom.

In this project, I have modified the colors a bit to make it a little more romantic with shades of pinks and peaches. We'll paint a magnolia stem with one big flower in full bloom, one about to open up and the third with the petals still closed.

For the petals, we'll add multiple layers of different shades of pink and peach for that extra detail while keeping the leaves relatively simple and letting the color contrast shine. Do not get overwhelmed by the details here; follow one step at a time and one petal at a time, and I am sure you'll be proud of the final result.

Let's do this!

COLOR PALETTE / PAINTS

A	B	C	D	E
Flesh Tint	Flesh Tint + Spectrum Red	B + Spectrum Red	E + White	Primary Red + White

F	G	H	I	J	K
G + White	Primary Red + Black	Yellow + Black + White	Yellow + Black	Black	Raw Umber

TOOLS AND MATERIALS

Sketch (page 123)

Carbon paper (optional)

Watercolor paper (300 GSM hot-pressed paper recommended)

Round brushes sizes 2, 0, 1 and 4

Gouache paints

Painting palette

Two cups of water, one to wash your brushes and the other to mix with the paints

Paper towel, to clean the brushes and soak up excess water and paint

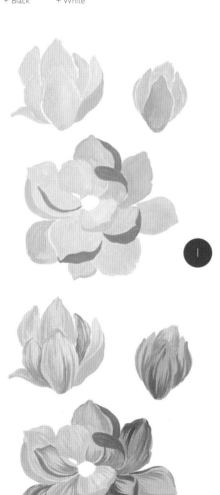

1. Trace or copy the sketch from the back of the book onto your watercolor paper. If you choose to use carbon paper, follow the manufacturer's instructions to transfer the floral design.

Start these flowers by painting the base layer with four different colors: A, B, D and E. Use A and D for the top of the petals and B and E for the turns and wherever the underside of the petal is revealed.

Start with one petal, using a fine-tip (size 2) brush, and keep in mind the slightly round and pointed ends of the petals. Leave a little white space between two petals.

2. Take a size 0 or size 1 brush and with colors B and E, start painting strokes from the base of every petal. We can also start filling the white gaps between petals with those same colors. Keep the direction of the strokes the same as the direction of the petals. Try keeping the consistency a little thick even if your strokes appear slightly dry; this technique adds a nice texture on the surface.

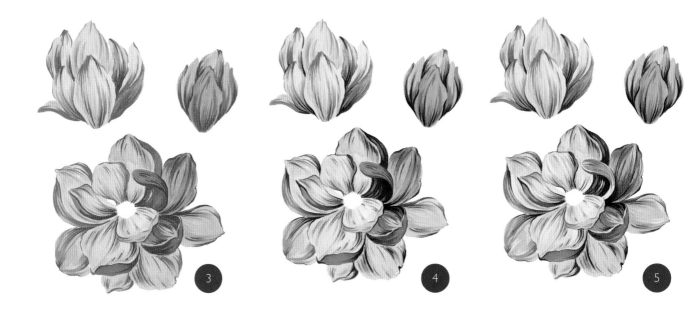

3. Now, you can start layering the flowers with a new color in each step. Here, use colors C and F to add strokes exactly the way you did in the previous step but keep them shorter in length so that the previous layer does not get hidden. Start the strokes from the places where the petals are emerging, the overlaps and ends of the bends.

Paint the inner bends of the petals to add a sense of depth and wave on the petal.

4. The next layer of strokes are the shortest; try painting this layer on the ends of the petals and over the intersection points. Use a fine-tip size 0 brush and color G to add shadow and depth.

5. Now that our shadows are done, let's move to some highlights. Take the color white with a creamy consistency and with a size 0 brush, start painting short strokes on the surface and toward the outer curves of the petals. The contrast between the shadow strokes and the white will create a beautiful sense of depth and dimension.

6. In this step, we'll paint the center of the open flower. If we think of it as a triangular structure, start with painting from the bottom of this triangle.

Take color K on a size 1 round brush and, holding the brush at a 45-degree angle, start stippling toward the top center of the triangle.

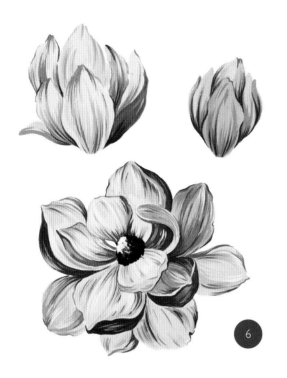

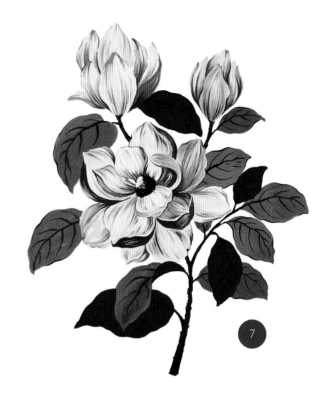

Next, take black, color J, and start stippling the same way from the bottom covering the base and three-quarters of the triangle.

At the end, take white and stipple at the top, covering about one-quarter of the triangle.

7. For the final step, take a size 2 round brush and paint the stems with color K. Keep the edge of the stem irregular and bumpy to make it look more natural. Next, paint the leaves with two shades of green, colors H and I, using a size 4 round brush. Once this layer dries, use colors I and J to paint the veins of the leaves with a size 1 round brush.

Start painting the main veins from the base of the leaves and move along the bend of the leaf. This will give a direction and further branch it on both sides to create the side veins.

HOLIDAY FLORAL

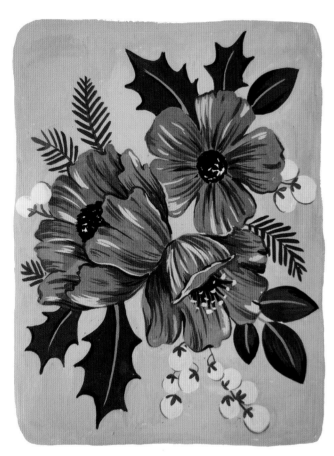

To be honest, I have taken a slightly more whimsical and imaginative approach here. I wanted to create a fun bunch with a subtle vintage holiday vibe using pastel blue and red without having the restriction of any particular flower or shape.

I decided on a modified version of a five-petal flower with a top as well as a side view, and once I was done painting the artwork, I had to share this project with you. Using layers of thick paint in shades of reds and big bright strokes, we'll paint a holiday-ready project.

Add a "Merry Christmas" to this composition and I can already see a Christmas postcard shaping up.

COLOR PALETTE / PAINTS

A	B	C	D
Background Indigo + Green + White	C + White	Spectrum Red + Grey	C + Black

E	F	G	H	I
Green + Black	Yellow + Black	F + White	F + Black	Black

TOOLS AND MATERIALS

Sketch (page 124)

Carbon paper (optional)

Watercolor paper (300 GSM hot-pressed paper recommended)

Round brushes sizes 6, 2, 4, 0 and 1

Gouache paints

Painting palette

Two cups of water, one to wash your brushes and the other to mix with the paints

Paper towel, to clean the brushes and soak up excess water and paint

1. Trace or copy the sketch from the back of the book onto your watercolor paper. If you choose to use carbon paper, follow the manufacturer's instructions to transfer the floral design. Since the florals are focused in the center almost like a big patch, paint the background while leaving white space in the center for the flowers and leaves.

Use a thick round brush for this, size 6, and color A, leaving the area closer to the outline and the white space. For neatness and precision, take a thinner round brush, size 2, for the area closer to the flowers. For this step, you can keep the consistency opaque or translucent—it's entirely up to you. To achieve an opaque background, add a drop or two of water to either mix or reactivate your paint and start painting. You can gradually add more water if you feel the paint isn't smooth enough or too dry.

Add a few more drops of water for a watery consistency that will help you achieve a watercolor-like effect.

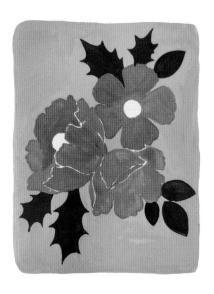

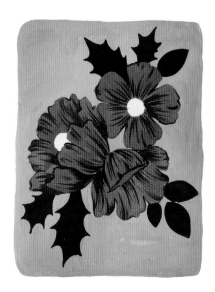

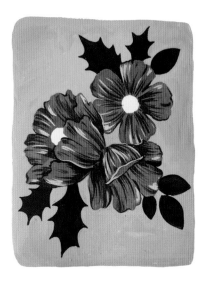

2. With a size 4 brush, paint the base for the flowers and the leaves with red, color B, and green, color E, respectively. Leave a little gap wherever there is an overlap between the petals of the flowers. This will help mark the petals.

3. With a darker shade of red, color C, create upward strokes starting from the base of the petals toward the edge. Start the strokes keeping the tip of a size 2 round brush flat and gently raising the tip up as you approach the end of the stroke. In the same way, paint some strokes down from the edge of the petals towards the base. The important thing here is to keep the strokes in the direction of the folds of the petal.

4. Take white in a size 0 or 1 round brush and create highlight strokes with white mostly toward the top of each petal. Keep the direction the same as step 3 but shorter in length.

5. Now let's add the last layer of shadow. Take the darkest shade of red, color D, and paint very short strokes starting at the base of the petal and overlaps. You can also paint wherever there is an inward curve.

To complete the flowers, paint the center of the two flowers using color I with a gentle stippling motion. For the third flower, paint upward strokes as if they were all originating from the center of the flower.

6. Paint the veins of the leaves with a size 2 brush and color G, gently lifting your brush toward the end so that the vein becomes thinner.

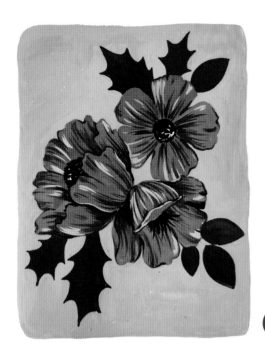

5

Paint the remaining leaves with the same brush and color F. Start with painting the main vein followed by painting lines in both directions. Keep your brush at a 45-degree angle and keep the leaves parallel to each other.

Once this is done, take white paint and, without adding too much water, paint the round buds. Once it dries, paint the small green leaves on the white buds with color E and a size 1 round brush.

Finally, use color H to paint the inward curves of the big leaves and paint the strokes on the ends of the smaller leaves.

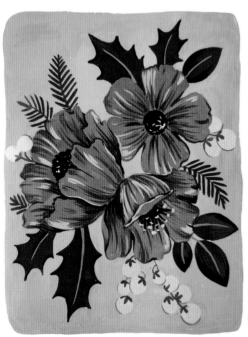

6

Tropical Botanicals

My first big tropical illustration was a wall mural for a café in Mumbai when I had just started painting with gouache. This was the first time I got to paint a large tropical artwork, and the big flowy leaves and the gorgeous color palette of blues and greens were a delight to work with. Since then I have painted a ton of tropical artworks for various murals and other projects, the most recent one being at a café in Prague.

From big green monstera to the elegant bird of paradise, the colors, the cuts on the leaves and the majestic form of tropical botanicals are difficult to ignore. A lot of tropical plants feature these characteristics—no wonder they are finding a place in people's hearts and homes all across the world.

In this chapter, we'll paint oversized leaves in different colors along with some tropical flowers like hibiscus and protea, and we'll paint compositions with multiple forms and shapes.

I am excited to get started with this chapter; go all tropical and play around with a lot of bright colors.

HIBISCUS

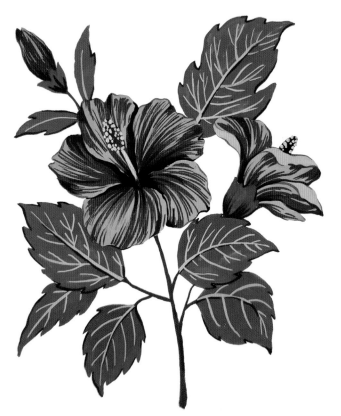

One of the most popular and vibrant tropical plants is the hibiscus. It has beautiful bright red petals and an interesting center that makes it very recognizable. In this project, we'll use bright shades of red and green and paint a hibiscus branch with two blooming flowers, a bud and plenty of lush green leaves.

We'll use the wet-on-dry technique to create a rich texture on the petals and a web of veins on the leaves. The contrast between the bright red and green will instantly make the entire flower pop.

COLOR PALETTE / PAINTS

A	B	C	D
Flesh Tint + Spectrum Red	Flesh Tint	Primary Red	C + Black

E	F	G	H	I
Ochre + White	Green + Grey	F + White	Raw Umber + Black	Black

TOOLS AND MATERIALS

Sketch (page 125)

Carbon paper (optional)

Watercolor paper (300 GSM hot-pressed paper recommended)

Round brushes sizes 4, 1, 0 and 2

Gouache paints

Painting palette

Two cups of water, one to wash your brushes and the other to mix with the paints

Paper towel, to clean the brushes and soak up the excess water and paint.

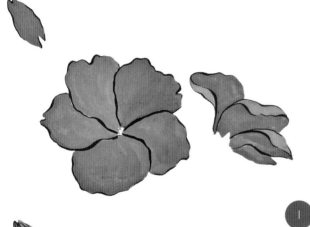

1. Trace or copy the sketch from the back of the book onto your watercolor paper. If you choose to use carbon paper, follow the manufacturer's instructions to transfer the floral design.

Start by painting the petals of the hibiscus flowers and the bud with a size 4 round brush and color A. The top of the petal has curves and waves; keep the edge uneven for a more natural look. For the bends of the side view flower on the right, use color B. Once done, paint an irregular outline of the petals using color D. Increase the pressure of the brush at the inward turns to make the outline thicker and go all the way around.

2. Next, take a bright red, color C, and with a size 1 round brush, cover the petals with long and short strokes, some starting from the center toward the end and vice versa. Use the tip of your brush while painting these and keep changing the size of the strokes for an interesting texture. Repeat this for all of the flowers and petals.

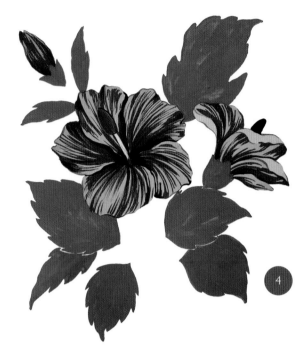

3. Once the previous color dries, take color D and, with the same round brush, start painting strokes at the overlapping points of the petals, toward the center and a few toward the ends and curves. This will create a sense of depth and shadow for the flower. Once the shadow is formed, take color I and with a size I brush, paint the center of the largest flower. Start from the center bottom and paint tiny strokes along the direction of the fold of the petals.

4. With a size 4 round brush, paint all the leaves with color F. Use the tip of your brush for the edges, and leave a little space where two leaves overlap.

To complete the flowers, let's add the stamen and pistils. Paint the tube-like structure emerging from the center with color B and the top with color H. For the flower on the right, paint the emerging central part with color H.

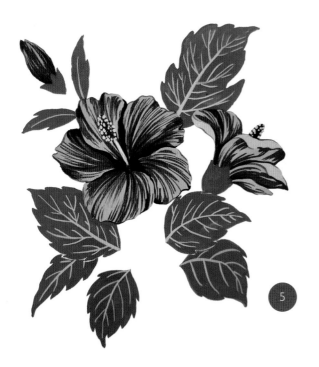

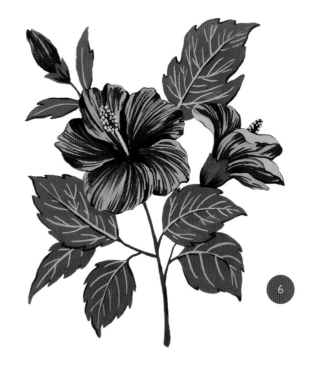

5. Once the base paint layer of the leaves dries completely, take a size 1 or size 0 round brush and start painting the veins in an irregular fashion. Take color G and start with the main vein running from the base of the leaf to the end. Next, start adding veins on either side of the main vein and further branch out to create an interesting vein structure.

Move back to the flowers and, using color E and the tip of a size 2 round brush, paint small dots to add pollen on the center of both stamens.

6. To complete the leaves and add shadow and depth, take color I and with a size 0 round brush, paint along the veins and the edges of the leaves. Consider this to be like a broken outline; paint certain areas along the edge and leave out certain areas.

To join everything together, take color F and paint all the stems of the flowers and leaves with a size 2 round brush.

MIGHTY PROTEA

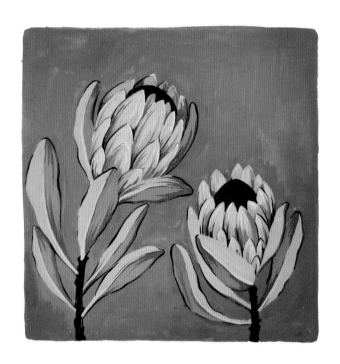

Protea blooms are becoming more and more loved by people all over because of their unique structure and size.

The largest species of protea, the king protea, is the national flower of South Africa and is also found in parts of Hawaii and California in the United States.

In various shades of pink, white and red, these flowers come in all shapes and sizes. In this project, we'll use shades of pink for the flowers with a prominent black center and large green leaves.

Since the outer petals of this flower are placed close together, we'll use multiple layers of color to add shadows, texture and detail. With the addition of each layer of color, the protea will get closer and closer to looking like the magnificent flower it is.

COLOR PALETTE / PAINTS

A
Background
Indigo + White

B
Yellow + Black
+ White

C
B + White

D
C + White

E
Flesh Tint +
Primary Red

F
E + White

G
Primary Red
+ Charcoal Grey

H
G + Black

I
Black

J
Raw Umber
+ Black

TOOLS AND MATERIALS

Sketch (page 126)

Carbon paper (optional)

Watercolor paper (300 GSM hot-pressed paper recommended)

Round brushes sizes 6, 2, 1, 0, 3 and 4

Gouache paints

Painting palette

Two cups of water, one to wash your brushes and the other to mix with the paints

Paper towel, to clean the brushes and soak up excess water and paint

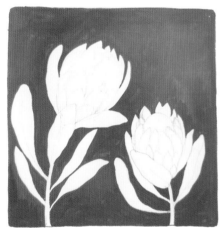

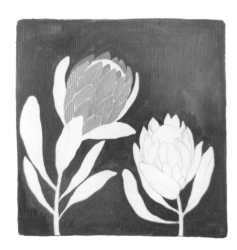

1. Trace or copy the sketch from the back of the book onto your watercolor paper. If you choose to use carbon paper, follow the manufacturer's instructions to transfer the floral design.

Let's start with the background and paint only the background first with color A, leaving the protea part white. Since the sketch is not complex, painting just the background becomes easy. Take a size 6 round brush to paint the bigger areas and a size 2 brush for an outline closer to the flowers.

2. Next, let's paint the larger flower first and then move on to the smaller one. Take the two light shades of pink, colors E and F, and paint the base of the larger flower with a size 2 round brush, one petal at a time. Use the darker color, color E, for the petals toward the back. Leave a little space at the intersection of the petals for the next step.

3. Now it's time to start layering up the petals on the larger flower and make them pop. Take color E and with a size 1 brush, paint the white areas and create upward strokes at the base of each petal. This is essentially to mark the overlaps.

4. Take color G and with a size 0 brush, repeat the above step for extra depth. Remember to keep the strokes this time shorter than step 3 so that it doesn't hide them.

Create short gentle strokes starting from the base with the tip of the brush and gently lifting the brush up.

5. For final shadows, take color H and with a size 0 round brush, again repeat step 4, this time keeping the strokes shortest and just touching the base and slightly to the left of each petal.

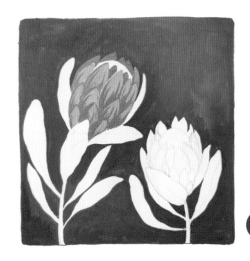

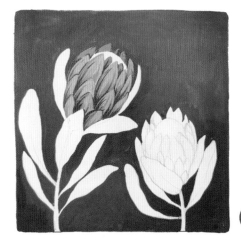

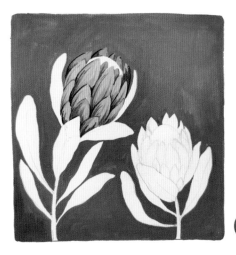

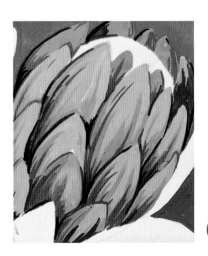

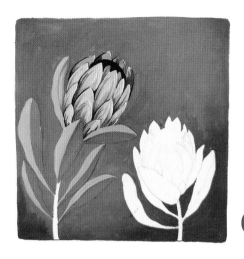

6. Take the color white and create small highlight strokes along the curve of the petals to add dimension.

Take color I and fill in the center of the flower with a flat application. With this step, our flower has already started looking alive.

Next, start painting the base of the leaves. For this, let's divide the leaf into two along the center and paint the two sides with different shades of green, colors C and D. You can use a size 3 or 4 round brush for this.

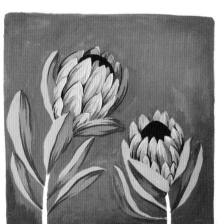

7. Repeat steps 1 through 6 for the second smaller flower.

For the leaves, take color B and start creating long upward and downward strokes along the darker side of the leaf.

8. For our final step, add a little white to color D on your palette and paint over the veins of the leaves with a size 1 brush; this will help add dimension to the leaves.

Once this is done, take color J and paint the stem with a size 2 round brush. Use stippling to add texture toward the edge of the stem and make it look uneven for a more natural look.

Our protea painting is done.

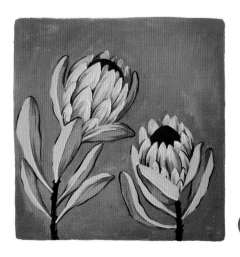

ANTHURIUM PATTERN

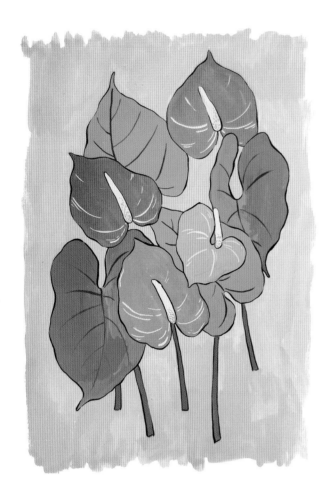

Anthuriums are known for their bright, uniquely shaped flowers and heart-shaped leaves. In this project, we'll paint anthuriums spread out over an ochre background with bright contrasting colors. We'll also give our artwork a slight graphic look using the outline technique and subtle lines. Once done, this can even act as a great motif for a repeat pattern.

While painting this project, feel free to change the color of the background to a color of your choice or go with no background for a simple, clean effect.

COLOR PALETTE / PAINTS

Ochre + White | A + White | Primary Green + White | C + White | D + Yellow + White

 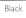

Primary Red + White | F + White | Flesh Tint | Primary Green + Black | Raw Umber | Black

TOOLS AND MATERIALS

Sketch (page 127)

Carbon paper (optional)

Watercolor paper (300 GSM hot-pressed paper recommended)

Round brushes sizes 4, 2, 1 and 0

Gouache paints

Painting palette

Two cups of water, one to wash your brushes and the other to mix with the paints

Paper towel, to clean the brushes and soak up excess water and paint

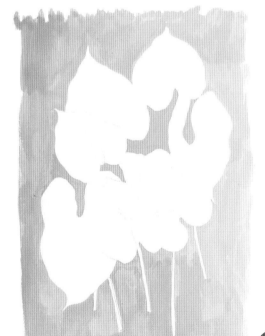

1. Trace or copy the sketch from the back of the book onto your watercolor paper. If you choose to use carbon paper, follow the manufacturer's instructions to transfer the floral design.

To start, let's paint the background with color A using a size 4 round brush. You can switch to a size 2 brush closer to the outlines for a more precise and neater look. Try to keep your strokes in one direction (vertical here) so that even if the strokes are patchy, they have a flow. Do not worry about the patchy background; once you are done with the artwork you will see how that adds character rather than a flat background.

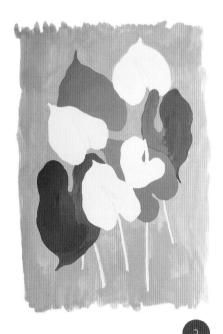 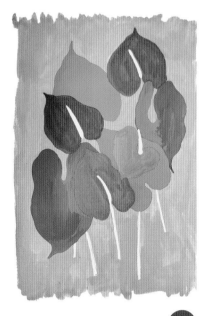 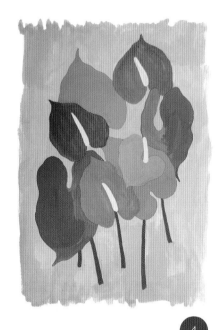

2. Since gouache dries pretty fast, your background will be dry in no time. Once that happens, rinse the same size 4 round brush and start painting the leaves. Paint the two leaves in the center with color E and the other two leaves on the left and the right with a combination of colors C and D. You can choose to paint one color first, wait for it to dry and then paint with the second layer, or you can paint with the two colors simultaneously while they are still wet for a more blended look. The former imparts a more graphic look, and that is what has been done here. Notice how the leaves are pointed toward the end and are broader toward the center.

3. Next, let's paint the flowers in bright shades of red and pink. Take a size 2 round brush and, starting from the pointed tip, paint the two flowers on the top with color F with a flat paint application. Create soft waves on the edges and leave out the center.

With the same brush and the same technique, paint the bottom two flowers with colors G and H.

4. Once the paint dries, move on to the center of the flowers that we had left in the previous step. Using color B and a size 1 round brush, paint the center with this light yellow color. Next, paint the stems with the same brush and color J.

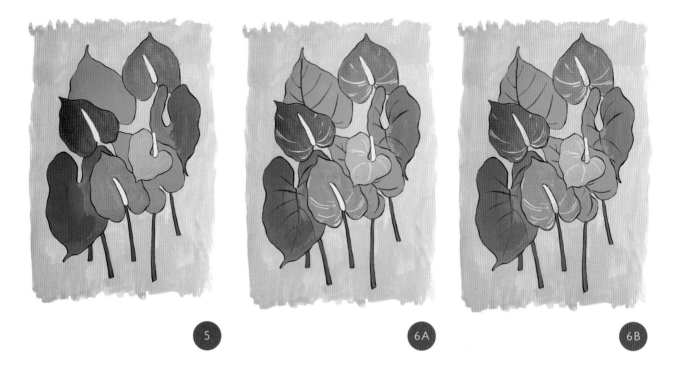

5

6A

6B

5. The base of the artwork is formed, and now it's time to move on to an important detail in this artwork: the black outline. The great thing about using a brush is that by increasing or decreasing the pressure on the tip, we can change the thickness of the stroke, and we are going to use this feature for painting the outline using color K. Take a size 0 round brush and start painting the outline of the flowers, leaves and stems. Try to increase the pressure wherever there are inward turns and curves. This will give you a beautiful uneven outline that gives an instant graphic look without making it look very flat because of the varying thickness of the outline and the patchy background.

6. Now, let's add the last few details to complete this artwork. Take color I and with a size 0 round brush, paint the veins on the leaves. For the flowers, take the color white and with the size 0 brush, paint lines starting from the center toward the ends. Make sure these lines as shown in image 6A are curved and follow along the curves of the flowers. Moving on to the center of the flowers, add a few dots at the bottom with color E and a few dots with white at the top, as shown in image 6B.

GRAPHIC MONSTERA

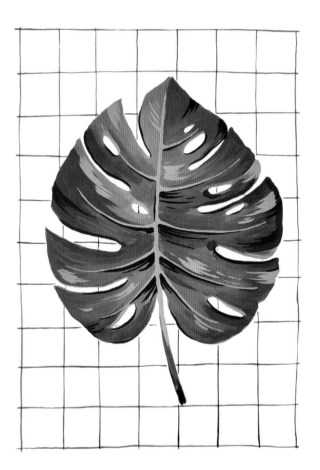

I have a thing for monstera, and I am positive that it's the large size, cuts and holes and big glossy green leaves that makes it stand out.

It is native to the tropical rainforests of southern Mexico, but we can all see its growing influence around the world, especially in prints for wallpapers, fabrics, stationery and so forth. Even though this isn't a floral project, I am sure you'll find plenty of use for this leaf either by itself or along with other tropical flowers.

We'll use both wet-on-wet and wet-on-dry techniques here to create a subtle play of greens and a graphic background for people who like a more minimalist look. The best part about this project is that you can feel free to play around with greens; the more you explore and enjoy, the better it will turn out to be.

COLOR PALETTE / PAINTS

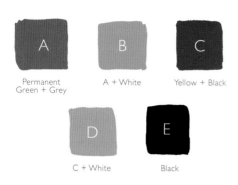

A — Permanent Green + Grey

B — A + White

C — Yellow + Black

D — C + White

E — Black

TOOLS AND MATERIALS

Sketch (page 128)

Carbon paper (optional)

Watercolor paper (300 GSM hot-pressed paper recommended)

Flat brush size 2

Round brush size 2 and 1

Gouache paints

Painting palette

Two cups of water, one to wash your brushes and the other to mix with the paints

Paper towel, to clean the brushes and soak up excess water and paint

1. Trace or copy the sketch from the back of the book onto your watercolor paper. If you choose to use carbon paper, follow the manufacturer's instructions to transfer the floral design.

Take two different shades of green, A and B, and with a size 2 round brush, start painting the left half of the leaf with both colors simultaneously, using the wet-on-wet technique. Taking small areas at a time, paint a part of the leaf with color A and the other with B and blend the colors where the two meet to create a soft blended look. You'll also notice a third color appearing in the areas where colors A and B merge. Try to blend both the colors while they are still wet. You can also paint one shade on one edge and the other on the other edge and let them merge naturally.

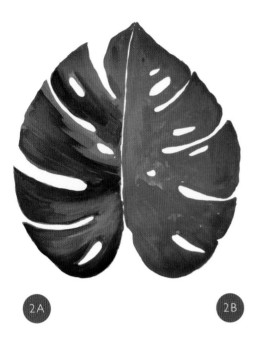

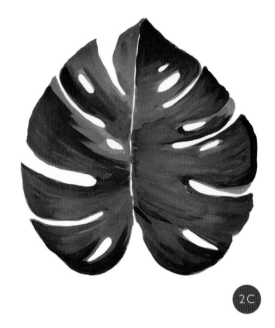

2A 2B 2C

Have fun while you do this step because there is no wrong way of doing it. The two colors and the blend will give you an interesting base and gradation for the leaf. In fact, use as many shades as you'd like.

2. In this step, I'll show you two different methods for blending all the various shades of green. Read through both methods and choose which one woks best for you.

For the first method, shown in image 2A, take a slightly wet size 2 flat brush and gently merge the two different shades using flat strokes starting either from the central vein to the left end of the leaf or the other way around. This will give the leaf a direction and make the blend in the previous step neater.

Keep repeating this; you can also take a little more of color A or B each time until you are satisfied with the base shade of the leaf.

Remember to keep the gouache consistency slightly thick here.

For the second method, shown in image 2B, start with a flat coat of green. Allow to it to dry, then take a darker shade of green, color A, and create flat strokes with a size 2 flat brush horizontally in the direction of the cuts. Take some water to reactivate the base layer while you do this to help merge the two colors wherever needed.

For both methods, your final result will be a fully blended leaf, shown in image 2C.

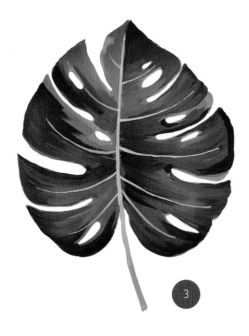

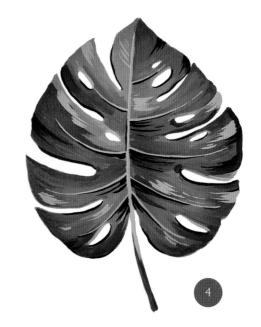

3. With a size 1 round brush and the lightest shade of green, color D, paint the veins and with color B, paint the stem of the leaf. You'll notice how beautiful the monstera has already started looking.

4. Now is the time for my favorite bit: adding final touches in the form of shadows and highlights.

Let's start with the highlights; take the same color as the veins and create short strokes along the direction of the veins.

Similarly, take the darkest shade of green, color C, and create shadow strokes along the veins, stem and the edge of the leaf.

5. To complete this artwork, I have painted a grid behind the monstera with color E. I love how the uneven crisscrossing lines look with the monstera and instantly make it into a finished statement piece with a graphic look.

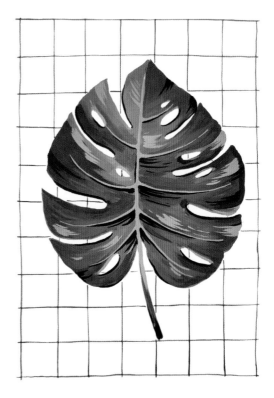

Succulents

Succulents are plants with fleshy leaves containing sap. They have been a popular choice for the longest time when it comes to indoor plants, partly because they come in a wide range of shapes and sizes and need very little care and partly because they are stunning to look at and can instantly jazz up any space.

Two years ago, when I moved out of my parents' house and to another city, I wanted large succulents in every corner of my apartment because I had a bold green and white color palette in mind, and succulents seemed to fit so well.

Unfortunately, I couldn't find most of the succulents I was looking for, so I decided to paint some and put them on my wall instead. The great thing was that because of their distinct shapes, even with minimal detail you can identify these plants.

In this chapter, we'll paint different types of succulents in various arrangements, for example, a glass terrarium. We'll also learn some easy techniques to create textures and thorns on leaves with multiple shades of greens. We'll also see how the addition of one contrasting color can increase the piece's impact.

If you have succulents at home, please do keep them in front of you while we paint this chapter. Having a live inspiration is the best way to paint anything, and this will help you study details and get the hang of it sooner and better.

BUNNY EARS CACTUS

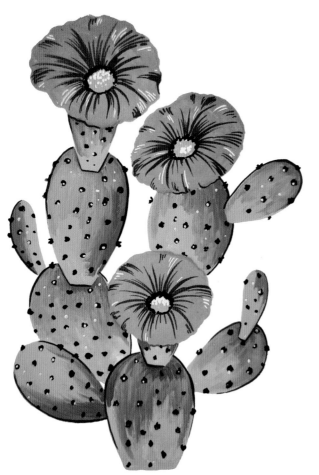

The cactus we are going to paint is commonly known as bunny ears because of its shape. In this project, we'll paint the leaves of the cactus using wet-on-wet technique for a soft blended look and complete the artwork with round rust flowers.

We'll also learn how to add a prickly texture to the leaves of the cactus using dots and a little stippling technique using pastel tones of green and red.

In this project, we are primarily using shades of red and green with a hint of yellow. Even though these are three generic colors, you'll notice that just the variation in shades and the use of multiple tones of the same color can drastically enhance the overall outcome.

COLOR PALETTE / PAINTS

A

Flesh Tint +
Spectrum Red

B

Primary Red +
Grey + White

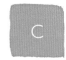

C

Ochre + White

D

Winsor Green +
Grey + White

E

D + White

F

Winsor Green +
Black

G

Black

TOOLS AND MATERIALS

Sketch (page 129)

Carbon paper (optional)

Watercolor paper (300 GSM hot-pressed paper recommended)

Round brushes sizes 2, 4 and 1

Gouache paints

Painting palette

Two cups of water, one to wash your brushes and the other to mix with the paints

Paper towel, to clean the brushes and soak up excess water and paint

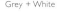

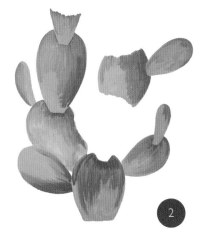

1. Trace or copy the sketch from the back of the book onto your watercolor paper. If you choose to use carbon paper, follow the manufacturer's instructions to transfer the design.

Start with painting the fleshy leaves with colors D and E using a round size 2 brush. These two colors will form the base for all of the leaves. Let's take two leaves first and begin by painting the base of the leaves with color E. Since we are using the wet-on-wet painting technique, while color E is still wet, take color D and start painting strokes from the left or right of the leaf and let it blend with the base layer toward the center.

2. Follow the above technique for all of the leaves. Use the darker color near the place where another leaf starts. That's the area where the shadow of the top leaf will be formed.

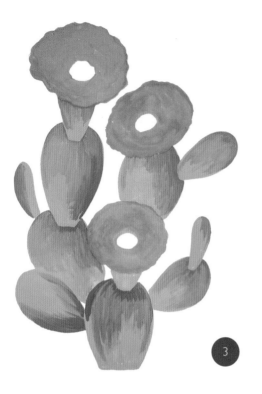

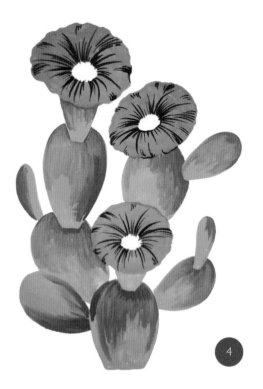

3. Once the leaves are painted, take a size 4 round brush and, with color A, paint the flowers in a round motion and create an uneven edge. Leave out the center of the flowers.

4. Next, take color B and a size 1 round brush. Starting from the center of the flowers, paint strokes toward the edge. Keep painting long and short strokes in all directions, gently moving the paper in a round motion. Also, paint a few short strokes from the edge toward the center. If you notice, the flowers now have dimension and have started to look 3D rather than flat.

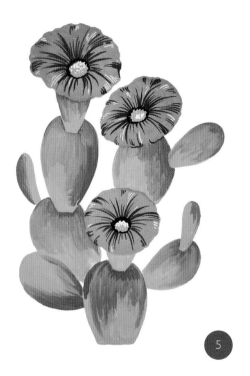

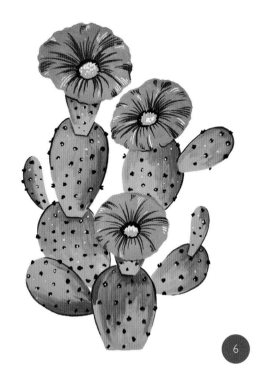

5. To complete the flowers, stipple in the center. Start with color G. Once it dries, stipple again with color C, leaving an outline of the previous layer. Once this dries too, stipple with white on one part of the center, covering just about half.

With the same white color, paint short highlight strokes on the flower, starting from the edge toward the center. These are the areas that would reflect light.

6. Moving back to the leaves, take color F and with a size 1 round brush, paint an irregular outline around the darker areas of the leaves. Next, paint uneven dots on the surface of the leaves using black, color G. Vary the size and shape of the dots for a more natural look. Once dry, paint tiny white dots randomly on the leaves.

BLOOMING TORCH CACTI

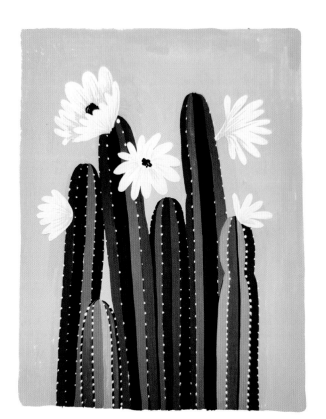

Cacti are the most common succulent and can be found in a number of shapes, colors and sizes.

Be it home decor or fashion, the cactus trend is spreading like wildfire, and everyone wants a piece of it either as a showpiece, print, plant or painting.

In this project, we'll paint a cluster of tall torch cacti placed next to each other with a subtle, contrasting vintage blue background and a muted green palette. We'll complete the artwork with bright white and yellow flowers at the top of our cacti. With a slight change in shape and style, you will be able to use these techniques for any cacti that you'd like to paint later.

Let's begin!

COLOR PALETTE / PAINTS

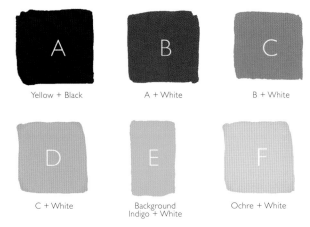

Yellow + Black

A + White

B + White

C + White

Background
Indigo + White

Ochre + White

TOOLS AND MATERIALS

Sketch (page 130)

Carbon paper (optional)

Watercolor paper (300 GSM hot-pressed paper recommended)

Round brushes sizes 4, 2, 1 and 0

Gouache paints

Painting palette

Two cups of water, one to wash your brushes and the other to mix with the paints

Paper towel, to clean the brushes and soak up excess water and paint

1. Trace or copy the sketch from the back of the book onto your watercolor paper. If you choose to use carbon paper, follow the manufacturer's instructions to transfer the design.

Let's start painting with the cactus on the extreme right. All the cacti are divided vertically into stripes, which basically mark the shape of the plant.

Start by painting two alternate sections with color D and a size 4 brush.

2. Then paint the other sections with different colors of green, colors A, B and C. Keep the consistency of the paint thick so that they do not merge with one another; a thick layer of paint can even add to the texture.

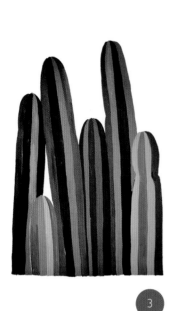

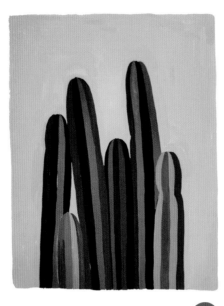

3

4

5

3. Keep painting the different sections with different colors until all of the sections are painted using the same size 4 brush; for smaller areas you can switch to a size 2 brush.

4. Next, paint the background of the artwork, the area around the cacti, with powder blue, color E, and a size 2 or 4 round brush. For areas close to the cacti, you can use a finer brush, size 1, to get the outline right. If you notice, the cacti and the background are covering two big separate areas in the artwork, which is why painting the background last is easy in this case.

At this stage, don't worry about the flowers. Paint the entire background and we can easily add the flowers over the blue paint later in the process.

5. Take a size 0 round brush and with white gouache paint, paint dots along the edges of the sections.

The dots will instantly lift the artwork up and make it look complete.

6. Now, let's add flowers to the plant. We have covered the entire surface of the paper already, but as mentioned earlier, the great thing about gouache is the ability to layer one paint over another. Sketch or transfer the flowers onto the blue background. Use white paint and a size 2 round brush to paint the flowers coming out of the cacti. For the large flower on the top left, leave a little gap between the petals. Cover the entire surface of the other flowers with white.

7. Once the white paint has dried, use color F and a size 0 round brush to add details on the flowers. Paint thin strokes from the center of the flowers toward the ends of the petals.

To complete the flowers, paint the centers using black paint, color A, and the tip of a size 1 round brush in a gentle stippling motion.

TERRARIUM

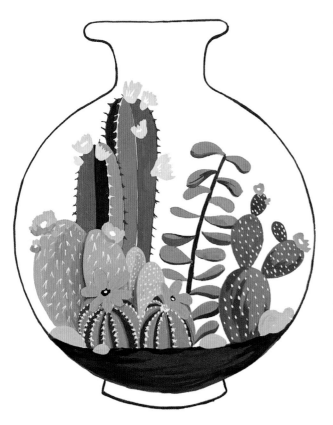

A terrarium is a closed glass container with a base of soil or gravel and plants. It can usually be opened to see and maintain the plants and then resealed.

A lot of terraria are packed with succulents because they need very little water and care and work extremely well indoors.

In this project, we'll paint a terrarium containing different types of cacti and a jade plant. We'll start with painting the base layer of the cacti, move on to the pointy details and finish it off with an outline of the glass container. You'll get to explore a number of techniques here, ranging from wet on wet and stippling to line drawing. Some details on the cactus might also test your patience, but it's all going to be worth it when you see the final result.

In this project, I'd recommend using as many shades of green as you can for depth and interest; just make sure the shades are close enough.

Taking care of a good terrarium might be tricky, but painting one doesn't have to be.

COLOR PALETTE / PAINTS

A	B	C	D	E	F
Charcoal Black	Permanent Green + Charcoal Black	B + White	C + White	D + White	D + Ochre

G	H	I	J	K	L
F + White	Raw Umber	J + White	Primary Red + White	Ochre + White	Flesh Tint + Spectrum Red + Grey

TOOLS AND MATERIALS

Sketch (page 131)

Carbon paper (optional)

Watercolor paper (300 GSM hot-pressed paper recommended)

Round brushes sizes 2, 0 and 1

Gouache paints

Marker (optional)

Painting palette

Two cups of water, one to wash your brushes and the other to mix with the paints

Paper towel, to clean the brushes and soak up excess water and paint

1. Trace or copy the sketch from the back of the book onto your watercolor paper. If you choose to use carbon paper, follow the manufacturer's instructions to transfer the floral design.

To get started with our terrarium, we're going to prepare four different shades of green: A, B, C and E.

The first cactus we are painting is divided vertically into three parts. For each of these, use a different shade of green and long vertical strokes with a round size 2 brush. Use the tip of your brush to mark the outline first and then make use of the length of your brush to paint inside. Let the first layer dry before you move on to the next or else you might end up smudging the two shades.

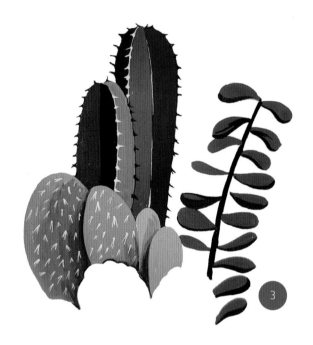

2. This step will turn your flat layers into a thorny cactus. You'll need two colors, A and a white, for this. Take a fine-tip thin, size 0 or 1, brush and paint the vertical edge of each segment. Using the tip of your brush, create pointy triangles, trying to keep them uneven and different from one another. Consider these as slightly bent, long cones with a pointy edge; some of these could even have two points coming out. Keep them tiny but big enough to see the shape.

I call this method layering and pointing, where you first add layers and then pointy thorns, and you'll find me using this a lot when I am painting a cactus.

Once done, paint the base layer of the second cactus with color E using a size 2 round brush. Move your brush either top to bottom or left to right but try keep the motion semicircular. Move on to the next step before this layer dries up completely.

3. While the base layer of our second cactus is still slightly wet, take a darker shade of green, color B, on the tip of the same brush and starting from the bottom and using the length of your brush, paint on the overlapping part just behind the small cactus. Paint around the bottom, slowly covering half of the cactus. Merge the color with the base color as you move away from the overlapping line and, if needed, go over the overlap so that the darkest shadow forms at the overlap. Add a slight gradient of the same color in a curved manner on the other cactus also.

Once the two layers dry, add tiny white strokes in the form of thorns. Use a fine size 0 brush and keep your hand firm on the table. Gently move your fingers, creating two or three lines all starting from one point. Paint the smallest and the third cactus in the same way with color G but without the thorns.

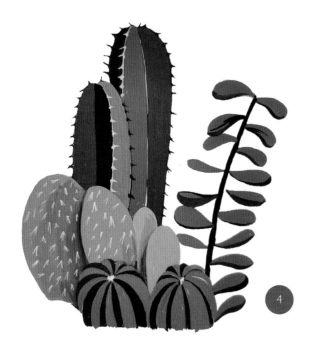

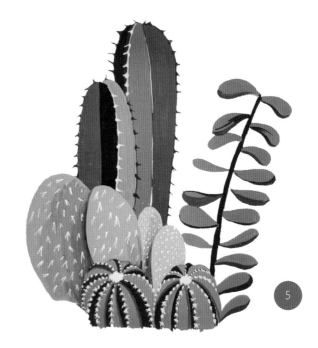

Let's move on to the jade plant now. Using color C, paint the base layer; these essentially have a curved teardrop shape in the horizontal direction.

Once the base layer dries, add shadows with color B toward the bottom curve of a few of these leaves. With color H and a size 2 round brush, paint a nice thick stem to complete it.

4. For the fourth cactus, we'll again start with painting the base layer with two different colors, A and F, alternately. Use any one color to paint alternate curved stripes first. Remember, they all have the same point of intersection at the top; keep them pointed at the top and wider as they come down. Once the first color dries a bit, repeat the step with the other color.

5. Paint small dots and crosses along the round edges of the fourth cactus and stipple at the center. Use the color white and a thin brush for this step. While you are at it, add texture to the third cactus that was painted with color G by painting tiny dots on the surface with the same brush and the same paint.

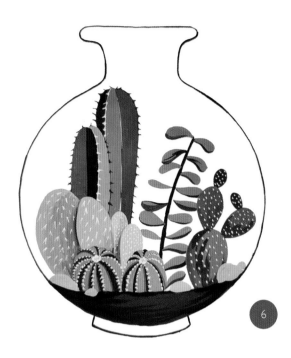

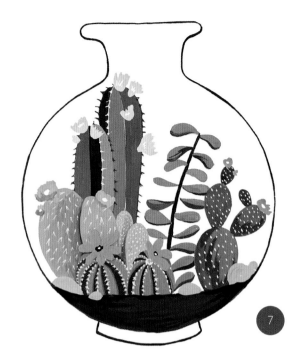

6. For the fifth and last cactus on the extreme right, paint a layer of color D in semicircular motions using the length of your size 2 round brush. Once the base layer dries, take color B on the tip of the same brush and create upward strokes starting from the base of this plant. Use the length of your brush and slowly move to the tip as you approach the end of the stroke. Finish this by painting white dots with the tip of your brush.

Paint the gravel with a flat coat of color G.

For the sand, paint the first layer with raw umber, color H, moving your brush horizontally. Once this layer dries, use color A to paint horizontal strokes at the bottom and both ends of the sand.

Paint an outline of the terrarium with charcoal black, color A, and a size 2 round brush or a marker.

7. To add flowers to the cacti, use a size 2 round brush and colors A, I, J, K and L on your palette. Starting with the tallest cacti, take color K and paint the florals using upward brush strokes. For the small round cactus at the bottom, take color L and paint the flowers with a flat application. For the center, use color A.

For the cactus on the left, take color I and with an uneven round motion of the brush, paint the flowers. While this layer is still wet, take color J and paint at the base of the flowers covering almost three-quarters of the area.

On the extreme right, following the above technique, paint tiny flowers using color L.

Once the base layer of the flowers has dried, take the color white and paint the centers of all the flowers in a stippling motion.

Botanical Typography

When you scroll down your feeds, there are countless text posts that you might end up ignoring just because they aren't catchy or colorful enough. As humans we are always more attracted to color and images than just black and white text. Now imagine a beautiful hand-lettered quote with flourishes juxtaposed with a botanical print. I am sure this would make you stop and look for at least a few seconds, if not inspire you to paint.

Botanical typography is a leading design trend where you combine hand lettering, calligraphy or a font with a botanical pattern in a way that adds value to the text and makes it more appealing to the eye.

With a small floral pattern, you can make your text stand out better and turn it into a refreshing work of art.

In this chapter, we'll learn how to combine the techniques we've used so far with alphabets, words and even a quotation or a phrase. Whether you are a hand letterer or a botanical art lover, I am sure this will take your skills to the next level by combining the two.

If you aren't too fond of hand lettering, do not get discouraged. Sticking to a simple bold font works just as well! The application possibilities of this chapter are endless, and I hope you enjoy this last chapter of the book and add a charming new touch to all your words and quotes from here on.

Let's start!

FLORAL LETTER

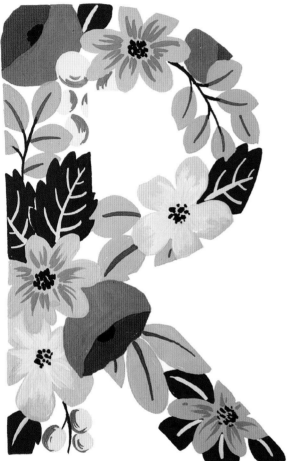

In this project, we'll learn how to paint a decorative alphabet with a floral pattern.

You can either use a single letter for drawing logos, writing initials or creating custom stationery, or you can paint multiple letters to form an entire word and create a finished artwork.

This project is also a little different from the other projects in this book because we'll learn the basic method and paint one letter using the sketch in the back of the book, but the agenda is to let you paint any letter of your choice.

There are two artistic elements to consider in this project. One is the botanical painting and the other is a bold letter of your choice. We'll learn how to juxtapose the two and create floral alphabets and, once you get the basic technique, you'll be able to paint any letter So, let's begin.

COLOR PALETTE / PAINTS

A

B + White

B

Blue + Red
+ White

C

Ochre
+ White

D

C + White

E

Spectrum Red

F

Primary Red
+ White

Flesh Tint
+ White

H

Green
+ White

I

Green
+ Black

J

Charcoal Black

Sketch (page 132)

Carbon paper (optional)

Watercolor paper (300 GSM hot-pressed paper recommended)

Round brushes sizes 2, 1, 4 and 0

Gouache paints

Painting palette

Two cups of water, one to wash your brushes and the other to mix with the paints

Paper towel, to clean the brushes and soak up excess water and paint

Tracing paper

Pencil

1. To create the floral letter R, trace or copy the sketch from the back of the book onto your watercolor paper. If you choose to use carbon paper, follow the manufacturer's instructions to transfer the design. If you want to create your own sketch for the letter of your choice, you can learn my method at the end of this project, on page 105.

Start with painting the three flowers with a light lavender, color A. Give it a nice flat coat with a size 2 round brush and wait for this layer to dry.

2. Once the light lavender is nice and dry, take a darker shade of lavender, color B, and a size 1 round brush and paint strokes on each petal in the direction of the petal. Consider them coming out from the same intersection point—that's the direction you want.

Start from the base of the petal and move toward the end, covering half or less than half of the petal space. Repeat this for all the petals and all three flowers.

Once this is done, let's move on to the five-petal yellow flower. With a size 2 or 4 round brush, create a base with a darker shade of yellow, color C, and repeat the above step for strokes on the petal with color D. This time do not wait for the base layer to dry completely. Using wet-on-wet technique, a part of both the yellows are going to merge together, giving you softer strokes.

3. Paint the base layer for the pink flowers that are facing sideways with a size 2 round brush. Use color F for the outside and E for the inside of the flowers.

4. Let's complete the flowers by stippling in the center with color J. Take a size 1 or 2 round brush and, holding the brush at a 45-degree angle, start stippling. This angle lets you use more than just the tip, leading to nice irregular bigger dots in the center.

Next, paint the base layer of the leaves with color I. Leave a little white space between the overlaps of two leaves to help you define the shape.

5. We are almost done with the key elements in this artwork, so let's move on to the smaller ones. Paint the leftover leaf branches with a lighter shade of green, color H.

To paint the cherries, paint a base layer with color G and wait for it to dry. Once dry, paint over one side of the circle with color E in a semicircular motion, creating two or three strokes. This will help you define the shape and add a shadow to the part that is away from the source of light.

> *TIP: To create the floral letter of your choice, draw your letter in bold on tracing paper. You can also trace an existing font from your computer. Next, place the letter on the floral pattern in such a way that the pattern covers the entire letter. Do not worry about containing the pattern within the letter; let some of it flow outside so that your forms are complete and not compromised. Once this is done, trace only the pattern that is inside the letter and erase the outline of the letter. Your floral letter is ready, and even without the outline, through the pattern you can easily make out the letter. You can follow this method for any letter.*

6. Next, with colors D and I, paint the veins of all the leaves. I have used a lighter green for the dark green leaves and vice versa.

Use a size 0 round brush for this and, using the tip of the brush, start from the base of the leaf and move toward the other end. We are done!

This was easier than you thought, wasn't it?

Now, sketch out the letter of your choice. With the help of the above steps, you can turn any alphabet into a floral one.

FLORAL WORD

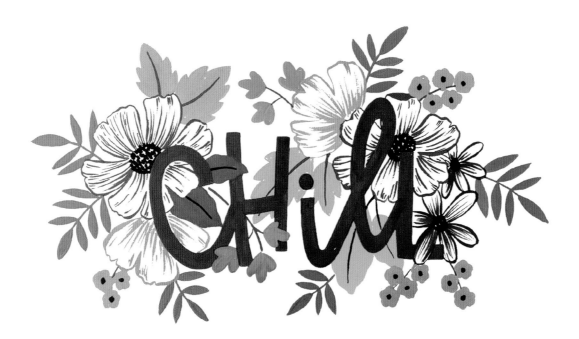

As the hand lettering on this artwork suggests, this is going to be a very chilled-out project with a lot of line drawing using gouache paint and the tip of a brush. Unlike other projects, we are going to combine flat application with line drawing in a monotone color palette for botanicals and a contrasting color for the type.

We'll be painting familiar flowers—cosmos, daisies and forget-me-nots—but with three different painting techniques: line drawing, flat application and stippling. Make sure you aren't wearing any jewelry on your wrist because the last thing you want is your jewelry interfering when you are trying so hard to keep your hand steady for the lines.

We'll start with painting the leaves and the flowers, and once we are satisfied with the botanical part, we'll make a move to the font.

COLOR PALETTE / PAINTS

A	B	C	D	E
Green + Grey	A + White	Prussian Blue + Green + White	Red + Blue + White	Charcoal Black

TOOLS AND MATERIALS

Sketch (page 133)

Carbon paper (optional)

Watercolor paper (300 GSM hot-pressed paper recommended)

Round brushes sizes 2, 1 and 0

Gouache paints

Painting palette

Two cups of water, one to wash your brushes and the other to mix with the paints

Paper towel, to clean the brushes and soak up excess water and paint

1. Trace or copy the sketch from the back of the book onto your watercolor paper. If you choose to use carbon paper, follow the manufacturer's instructions to transfer the floral design. We'll start by painting all of the leaves first with a flat application of two shades of green; they are easier than the flowers and will help define the overall shape of the project, so let's get these out of our way first. Use colors A and B and a size 2 or size 1 brush.

Notice how all leaves have a different shape and make sure it comes out well.

2. Now, we are good to move on to the flowers, starting with the cosmos on the extreme left using the line drawing technique. This is not an entirely new technique but a part of what we have already done in the previous chapters. First, paint the outline of the flower with color A using a size 0 or 1 brush. Keep alternating between the length and tip of the brush while you are painting the outline. You do not want a marker-like smooth approach. Let the line be thick at some places and thin at others.

Next, paint strokes from the center toward the ends of the petals and a few from the ends to the center.

3. For the center of the cosmos, take a size 1 round brush and, keeping the brush at a 45-degree angle, start stippling at the center with color E to create an interesting texture. You can already start to see how the different techniques—flat application, line drawing, stippling—interact with each other to create a beautiful artwork.

Repeat steps 2 and 3 for the other cosmos as well. For the two flowers with a side view, use color B.

4. In this step, we'll paint the smaller flowers; to create a sense of differentiation, use color C and paint the small flowers with a flat application. Leave the flowers with three petals facing sideways as they are. For the rounder forget-me-nots, paint the center with a dot using charcoal black, color E.

Paint the daisies using the same approach as the cosmos in steps 2 and 3. Here, keep the strokes closer to each other around the center.

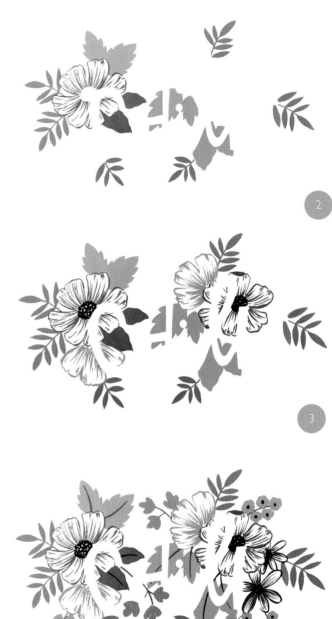

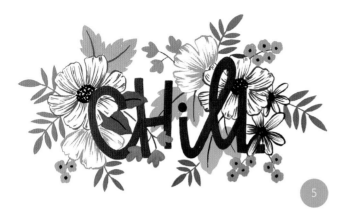

Add stems and veins to the leaves wherever needed.

> *TIP: While painting the florals, try not to cover the area with the typography, but even if the paint spills a little, don't worry because we are going to cover it with another layer of paint at the end and the mistakes will be hidden.*

5. Make sure all of the stems and veins are painted before we move on to the word "Chill," because that'll help you get a direction and flow to the artwork.

With color D and a thin size 1 round brush, paint the outline of the word. This outline helps you form the word; right now there is a lot surrounding the word, and it's always good to create definition first that will help you paint later.

With a nice thick consistency, paint inside the outline.

> *TIP: Our artwork is technically complete, but for a slightly 3D look, you could paint the shadow around the word. For this, take a size 1 round brush and paint on the left and the bottom of each letter.*
>
> *Imagine the light source to be on the top right; in this case the area that will receive minimum light is the bottom left and that's exactly what we are painting with charcoal black, color E.*

FLORAL QUOTE

A classic way to paint a quote and make it ten times more eye-catching is to paint a beautiful wreath around it.

To paint a wreath, always start with a rough pencil outline of the shape that you want and then start adding elements one by one. If you want a balanced wreath, keep similar elements placed at equal distance throughout. However, I find a little asymmetrical wreath more interesting.

In this artwork, we'll use two primary colors—yellow and blue—to paint an oval wreath and complete it by painting one of my favorite quotes inside.

COLOR PALETTE / PAINTS

A	**B**	**C**
Ochre + White	Ochre	Ochre + Raw Umber
D	**E**	**F**
E + White	Blue + Green	Charcoal Black

TOOLS AND MATERIALS

Sketch (page 134)

Carbon paper (optional)

Watercolor paper (300 GSM hot-pressed paper recommended)

Round brushes sizes 4, 1 and 0

Gouache paints

Painting palette

Two cups of water, one to wash your brushes and the other to mix with the paints

Paper towel, to clean the brushes and soak up excess water or paint

Brush pen (optional)

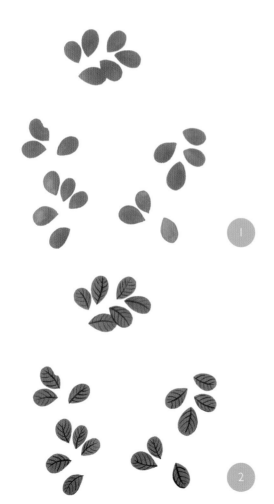

1. Trace or copy the sketch from the back of the book onto your watercolor paper. If you choose to use carbon paper, follow the manufacturer's instructions to transfer the floral design.

To start painting a wreath, it's a good idea to paint one element throughout first and then move on to the next. Here, paint the leaves with a size 4 brush using color D. The shape of the leaves resembles a water droplet; use the tip of your brush for the starting point and press for the remaining part of the leaf.

2. Once the base layer has dried, using color E and a size 1 fine-tip brush, paint the main vein of the leaves and then move on to the side veins. Keep the thickness of the side veins slightly narrower than the main vein.

3. Now, paint the base layer of the flowers and the buds using color A and a size 4 brush. Keep the edges of the petals crooked and leave out the center. We'll come back to this later.

4. To add details and texture to the flower, add strokes to the petals with a size 1 brush and color B. You'll notice that colors A and B are very close to each other in terms of the tone and you'll be able to achieve a very subtle tone-on-tone texture on the petals.

5. To add a little shadow to the flower and lift it up, take color C and add very few strokes to the overlaps, base and cuts of the petals. Remember, since the color is a relatively darker tone, just a few strokes will do the job.

6. Now, paint the center of the flowers with color F, and once it dries, paint a few dots with white to add a pollen texture. Make sure the layer with color F is completely dry before you start adding the drops. If it's even a little wet, the color might turn into a light grey or smudge.

Add small strokes of white on one side of the buds to add a highlight and paint the stems using color F and a size 1 brush.

The wreath is done. Finish this artwork by painting over the quote with black paint, color F, and a size 0 or 1 round brush.

You can also use a brush pen to write the quote.

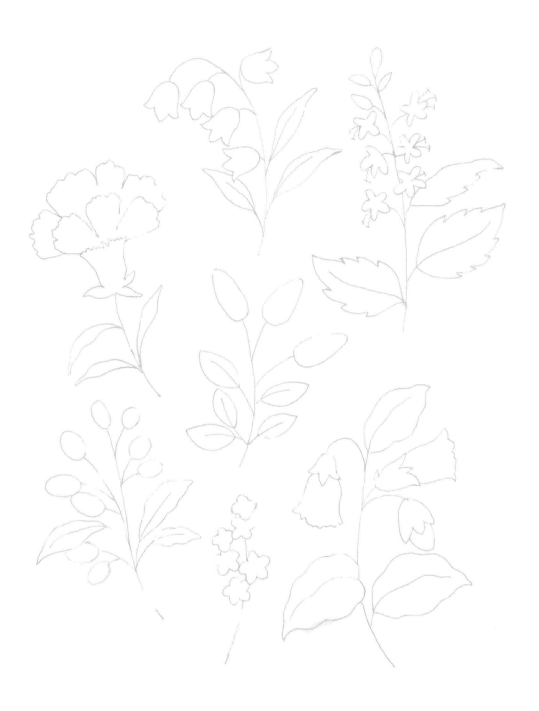

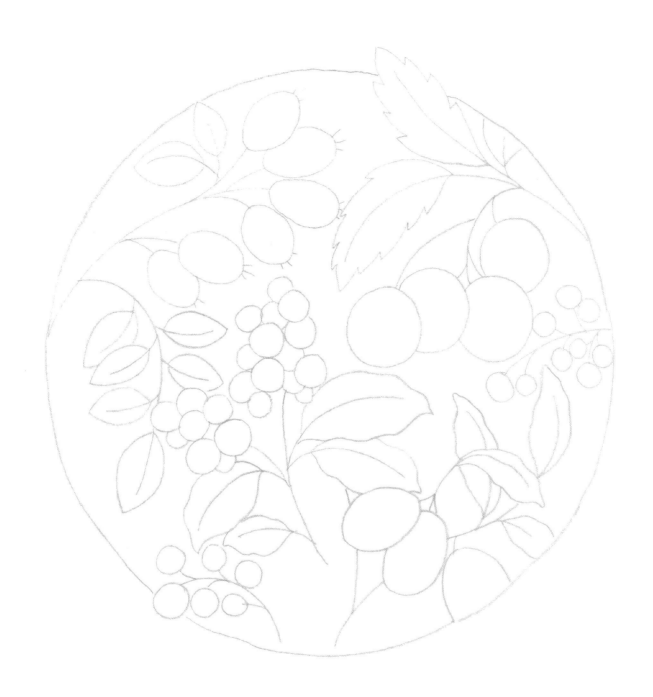

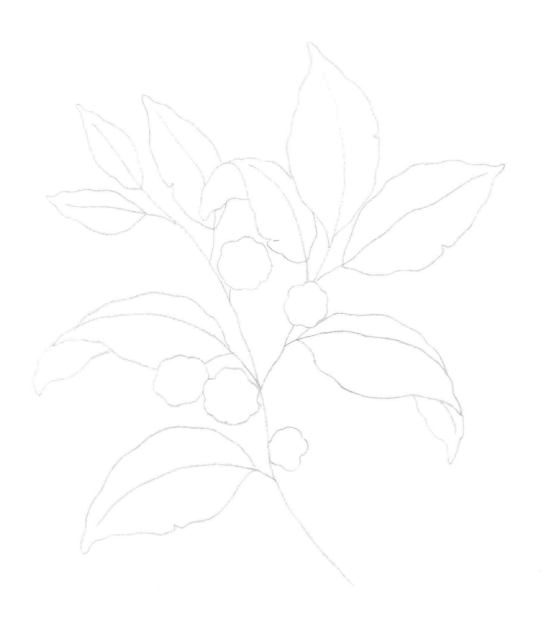

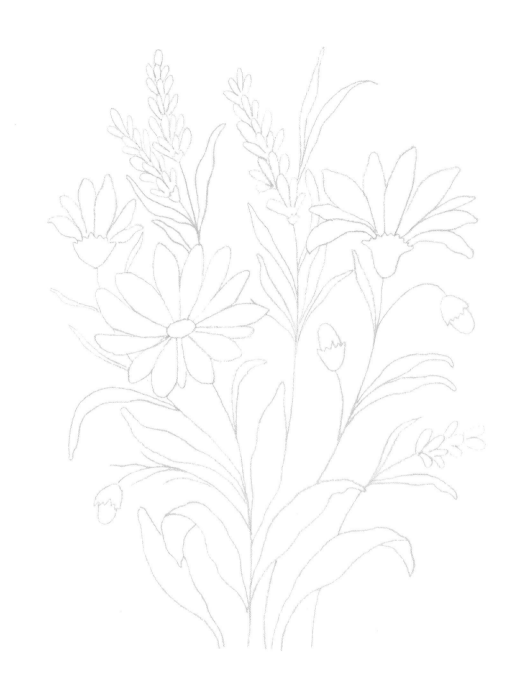

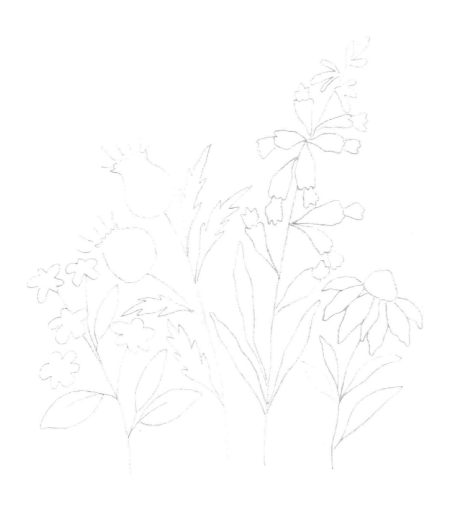

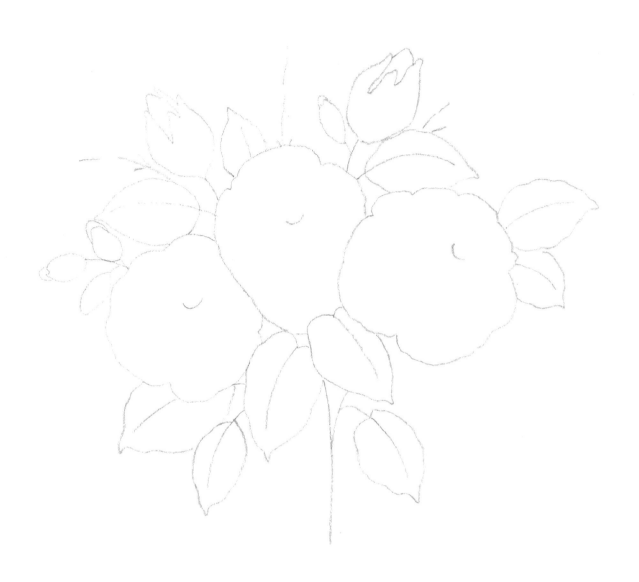

PAINTING FLORALS WITH GOUACHE

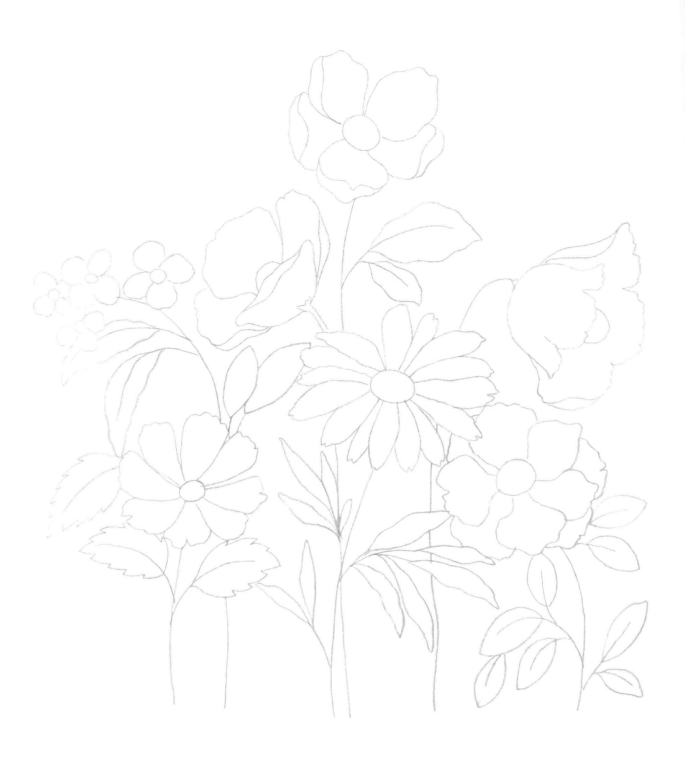

PAINTING FLORALS WITH GOUACHE

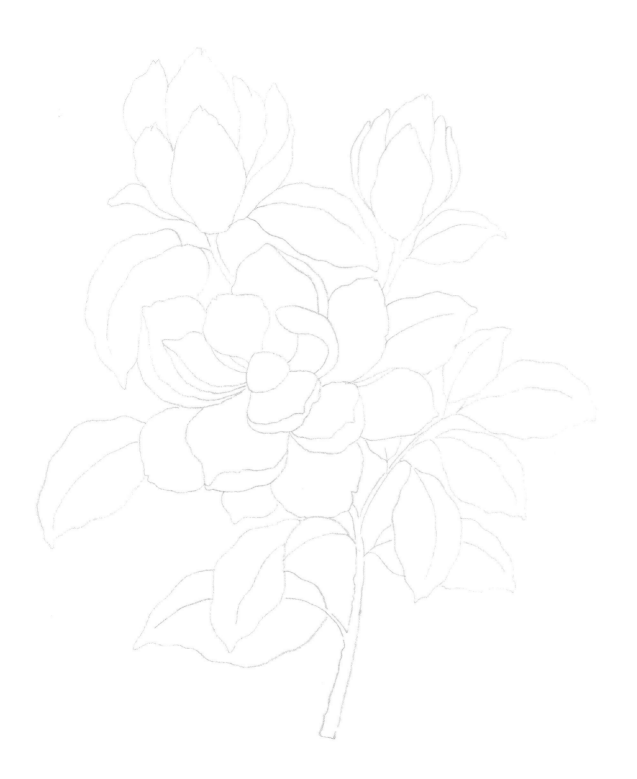

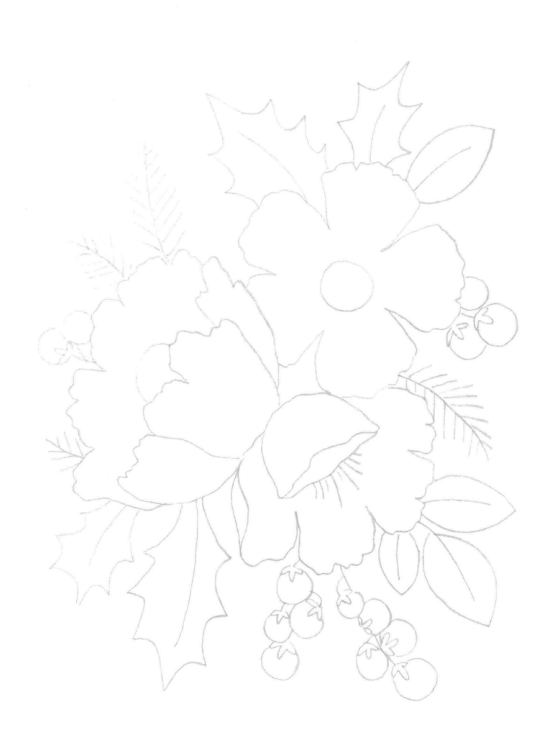

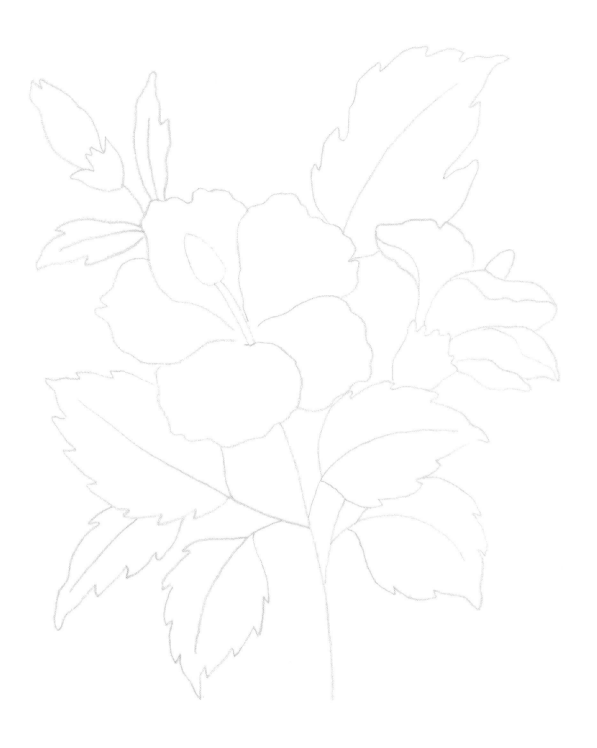

PAINTING FLORALS WITH GOUACHE

PAINTING FLORALS WITH GOUACHE

PAINTING FLORALS WITH GOUACHE

ACKNOWLEDGMENTS

I truly feel grateful, blessed and lucky to have the best people in my life who have helped me grow, learn and become a better version of myself.

First and foremost, a big thank you to my parents and family for encouraging me to pursue my passion and dreams, for always being by my side and believing in me even when things went downhill.

Thank you for teaching me the value of hard work, patience and love.

A special thanks to my best friend and fiancé Nikhil for lifting me up when I needed a push. Thank you for being by my side and motivating me to be better each day.

I'd also like to thank my amazing business partner Saurabh for his positive outlook, patience, believing in me and taking care of the brand while I took time off to work on this book.

To my best friends and mentors Priyanka and Sakshi, thanks for being a constant source of inspiration and guidance and being with me through the major decisions of my life. Without you, I would still be the clueless twenty-two year old in a grown-up body.

To all those who have been following my work, have attended my workshops or dropped messages or emails of appreciation, thank you for all the love and support. You guys encourage me to work harder.

This book would not have been possible without the team at Page Street Publishing and my editor, Rebecca. Thank you for giving me this opportunity, the creative freedom and for helping me along the way to make this dream come true.

ABOUT THE AUTHOR

Vidhi's passion for painting began at a very early age.

She kept the paintbrush close at hand through her childhood and adolescent years, before choosing to forge her career as an illustrator.

Her artistic talent coupled with an entrepreneurial spirit led to the founding of The Ink Bucket in 2015.

Planners, calendars, notebooks and wallpapers are some of the merchandise that carry the botanical artwork that form the core aesthetic of her brand.

Vidhi's journey to entrepreneurship and her work have been featured in a variety of publications and blogs, including BuzzFeed, Grazia, Yahoo Lifestyle, Ballpit magazine and Yourstory.

She is currently based out of Bangalore, India, and works full-time on The Ink Bucket designing and creating products that reflect her love for painting, art and botanicals.

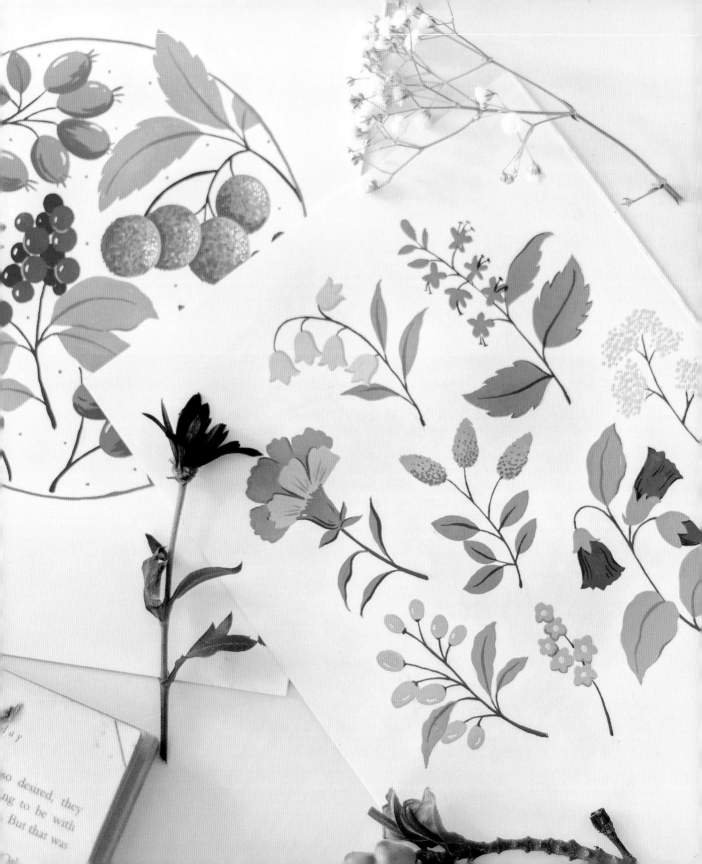

INDEX